How to Become a Professional Calligrapher

How to Become a Professional Calligrapher

by Stuart David

TAPLINGER PUBLISHING COMPANY, NEW YORK

First published in the United States in 1985 by
TAPLINGER PUBLISHING CO., INC.
New York, New York

Copyright 1985 by Stuart David
All rights reserved
Printed in the United States of America

The quotation from *The Once and Future King* by
T.H. White, which appears on page 69, is used
with the kind permission of the Putnam Publishing
Group, Inc.

Library of Congress Cataloging in Publication Data

David, Stuart.
 How to become a professional calligrapher.

 "A Pentalic book."
 1. *Calligraphy—Vocational guidance.* *I. Title.*
Z43.D244 1984 745.6'1'023 84-243
ISBN 0-8008-3959-5 (pbk.)

Contents

To Louis Strick, who, as president of Pentalic Corporation,
was first in this country to provide a line of calligraphic supplies
and who continues to encourage excellence in the field.

To Paul Freeman, who founded the Society of Scribes,
a forum for the exchange of ideas which gave impetus to the nation-wide growth
in the popularity of calligraphy.

To Alice, whose work exemplifies the highest standards of our craft.

How to Become a Professional Calligrapher

Introduction

We begin the practice of calligraphy because we enjoy it. Everyone likes the look of well-formed letters, but some of us actually take pen in hand and begin turning them out. We bring order to our handwritten pages and may experience a calming effect from the practice; our friends are sincerely impressed with our work and encourage us. Somewhere along the line we ask ourselves, "Can I make money out of this?" The answer is yes, and this book will tell you how to turn your craft from a hobby into a marketable skill.

For the beginner, calligraphy is essentially a cottage industry. Earnings are often sporadic and constitute a supplemental income. The clientele consists of private individuals, local shops, restaurants, printers, and so on. Advertising is usually by word of mouth. The work is billed at an hourly rate and done in evenings or weekends. but the part-time nature of his efforts notwithstanding, the beginning calligrapher is perfectly capable of producing work that is pleasing, effective, and—most important for our purposes—profitable.

In most cases, the beginner is someone who has learned italic and perhaps one or more other hands from studying books or taking courses. He works with a fountain pen or dip pen and has experimented with several different inks and papers. He has probably delved into the history of letterforms and related crafts like illumination or gilding. These investigations are usually spurred on by natural curiosity without a particular goal in mind. When the question of making money is posed, a goal is introduced and another question arises: How much do you have to know before you are ready to make money?

Many calligraphers recommend at least two years' study before marketing your work. I beg to differ. If you study seriously—an hour a day—you should be somewhat pleased with the result in a few weeks. When your work begins pleasing you, it will probably begin to please others. In two to three months, you should reach the level at which many people can begin earning money for their work.

I suspect my colleagues recommend a

longer start-up period for two reasons. The first is to uphold the standards of the craft; the quality of one's work is obviously much higher after two years than it is after two months. I feel there is room in the market place for both levels of work, beginner and advanced. If the advanced calligraphers want to make the finest work known, it is up to them to educate the public, not set restrictions on beginners.

The second reason is that calligraphers, as well as other artists and craftsmen, tend to be introverted, and shy away from business dealings. Happy in isolated work, they are not at home in the marketplace; rather than going out and selling themselves, they prefer to perfect their work until it speaks for itself. Both of these reasons are understandable, but if you intend to earn money, sooner or later you will have to take the plunge. You will progress faster by entering sooner. I have written this book for people who are not brash or aggressive, to show them the procedures for presenting their services in a simple, effective way.

Of course you can't expect to charge a lot for beginner-level jobs, and you won't get some jobs because your work is not good enough— yet. But you can progress more rapidly if you learn while you earn. Courses and books are a great help and you should continue to study, but your best instruction comes from meeting the requirements of someone who is going to pay you money for your work.

Just as craft skills take time and practice to develop, it also requires concentration and effort to master business skills. The first chapter of this book constitutes a primer on the fundamentals of selling your skills and negotiating with clients. The following chapters offer instructions and suggestions on the actual execution of beginner-level jobs. Each chapter presents additional craft information and a slightly harder challenge. If you complete the projects in these chapters, you will have quite a respectable portfolio.

Since this is a book on how to go into business as a calligrapher, nearly all the projects presuppose a basic understanding of how to use the tools of the graphic arts. In the same way I assume you have studied calligraphy and thus make no attempt to teach letterforms here, neither do I explain what a T square is or how to use one. If you are totally unfamiliar with the tools and terminology of graphic arts, you will probably want to buy a book or take a course in this field to supplement my instructions.

The beginning calligrapher is perfectly capable of producing work that is pleasing, effective—and profitable.

I believe there are two aspects to learning: theoretical and practical. The theory in this book will take you only so far. What you practice will take you much further. You will really begin to learn when you are not afraid of making mistakes, and you will learn even more by getting it right. Discovery is an inherent part of craft. None of the methods in this book is meant to be chiseled in stone. This is not an apologia but a credo: I believe that the only real method is that which we discover ourselves. I hope my methods give you a good foundation, but I also hope you grow beyond them through care and attention. After a certain point, refining a craft comes down to refining the craftsman.

Basic Business Practice

The biggest problem for most artists and craftsmen is selling. The creative person often has an introverted nature and shies away from ordinary business transactions, let alone sales tactics. Selling is often thought of—and practiced—as persuasion. But there is another method, especially suited for nonaggressive personalities, in which selling is simply a matter of presentation.

SELLING AS PRESENTATION, NOT PERSUASION

In this approach, selling isn't even as venturesome as, say, asking someone for a date. Actually, it's more like standing in the kitchen doorway at a party and asking, "Would anyone like some beer?" Most of the group will not answer. This is not depressing. A couple of people say yes. This is not elating. You just count up the "yeses" and retrieve that many beers. Selling can be like that. You just give an unvarnished presentation of your services to the right people and respond to their needs.

Your pitch is not a "hook" but a clear statement of what you have to offer. Whether you use the phone, the mail, or walk into offices unannounced, you need to sum up your services with as neat a phrase as "Would anyone like some beer?" Right to the point. Make it easy for the other person to say yes, no, or let's sit down and talk about it.

Disregard all thoughts about buyer resistance, personal rejection, and all that self-defeating rot. Either they can use your service—not *you*, but your service—or they can't. Prepare an opening summary statement and, in case they want to hear more, a follow-up discussion that goes into some depth. Just present it. Let them decide.

Your introduction to a new client should rarely be done in person. The best initial contact is made either by phone or mail. The opening statement and follow-up discussion are handled differently for these two approaches, and in the sections entitled "Selling by Mail" and "Selling by Phone" this difference will be treated.

FINDING CUSTOMERS In each of the project chapters, you will find advice on where to look for customers. For instance, in the chapter on addressing envelopes, it is suggested that you make your presentation to bridal shops, churches and synagogues, caterers, country clubs, and social organizations. Where do you get a complete list of any of these categories? The Yellow Pages are a good place to start; beyond that, a librarian can help you locate trade association journals that will help you get in touch with their members.

PROMOTION PIECES In presenting yourself as a professional, you need three items to show potential customers: a business card, a portfolio, and a flyer. (A possible fourth one is a sign outside your door. I have often felt that hanging up a shingle, beautifully lettered, could bring business in off the street. Perhaps it would work in your neighborhood.)

Business cards are useful because prospective clients keep them on file for future reference. Although the quality of your card demonstrates the quality of your work, it does not in itself sell your services. Furthermore, many people spend much too much time designing their business card because they see it as the embodiment of their own image. Try to avoid self-consciousness and remember that the function of the card is to represent the service you are providing. When in doubt, simplify. Just to get you started, I have provided examples of standard, effective designs you may adapt to your own needs (see Fig. 1).

The portfolio contains representative samples of your work arranged in an attractive and accessible manner. If a potential client needs some calligraphy, he will want to see if the quality of your work is appropriate to his needs. This is an aspect of selling where the work speaks for itself.

When you are first looking for work—addressing envelopes—you do not have to prepare anything elaborate. Just take a couple of samples along with you in a large envelope. As you complete assignments and accumulate samples, add to your collection and gradually replace your early, crude work. (Do not be dismayed at this apparent crudeness; it is actually an indication of your own advancing skill and sensibility.)

Document all your work. If you supply the artwork for a job the client is having reproduced make sure you get several printed copies. I rarely have trouble getting paid, but for some reason clients are slow in sending samples of the printed piece. Be gentle but persistent. These samples are the rungs of the ladder you are climbing to future jobs. If the job will not be printed, take a photograph, or have it photostated or reproduced on a copier. Color photocopies are excellent samples and quite faithful to the original. If you are addressing envelopes or filling names in on certificates, make a couple for yourself.

The theory in this book will take you only so far. What you practice will take you much further.

After you assemble a reasonable collection, lay out all the pieces on the floor. Putting a portfolio together is a little like designing a book. Put the best pieces at the beginning and the end. Do not design by individual pages but by spread (two pages facing each other). Spreads should be uncluttered and color-coordinated. Consider the sequence of pages in your design. Do you want to have six pages of envelopes followed by four pages of invitations followed by six pages of certificates...or, an italic section

Fig. 1

Barbara Smith
Calligraphy
12 Elm Street
Centralia, IL 62801
618-724-6019

Barbara Smith

Calligraphy

12 Elm Street, Centralia, IL 62801
618-724-6019

Barbara Smith
Calligraphy
12 Elm Street
Centralia, IL 62801
618-724-6019

Barbara Smith

Calligraphy

12 Elm Street, Centralia, IL 62801
618-724-6019

Barbara Smith
Calligraphy
12 Elm Street
Centralia, IL 62801
618-724-6019

Barbara Smith
Calligraphy

12 Elm Street, Centralia IL 62801
618-724-6019

followed by a blackletter section followed by an uncial section? Eliminate pieces that look alike and do not let it get overlong.

The least expensive type of portfolio is a three-ring binder with plastic sleeves to protect your work from becoming dog-eared by inquisitive fingers. Compare this with the more expensive portfolios available in art-supply stores and decide whether the better impression warrants the added expense. You can find binders in leather or plastic and in many different sizes.

The nature of your flyer changes according to your skill and the market you are approaching.

Look at the sizes of your pieces to determine which size sleeve you need. I have been able to fit almost all my work into the 11"×14" size, which is less cumbersome to tote around town than the thin suitcase size. (The larger one is useful as an overhead shield if you get caught in the rain, but in a high wind it turns you into a sailboat.) Affix your pieces to the black backing paper inside the sleeves with double-stick tape. The neatness of your presentation to a prospective client really counts.

The nature of your flyer changes according to the level of your skill and the market you are approaching. In the beginning it is quite reasonable to design a flyer on addressing envelopes and sending it to bridal shops, churches and synagogues, etc. After you try your hand at filling in names on certificates and invitations, you may design another flyer demonstrating all these services and send it out to an appropriately expanded market. In several of the project chapters I have provided sample designs for flyers. Since calligraphy courses rarely include instruction in graphic design, some of you may need help in this area. If you send out a poorly designed piece with pleasing calligraphy, you are not showing your work off to advantage. Until you are confident you've developed an eye for the arrangement of elements in a flyer, you might want to stick fairly close to the examples presented in this book.

To sum up, here are the preliminary steps to follow once you have decided to go into business as a calligrapher:

(1) Evaluate your present level of competence and choose the service(s) you are capable of providing.
(2) Decide who to approach with your service(s).
(3) Create your promotion pieces: business card, portfolio, and flyer.
(4) Present your services to the clients you have targeted. You may make the initial contact by phone or by mail, and we will discuss these two approaches now.

SELLING BY MAIL

The best approach to selling is to send out a flyer and follow it up within the week with a phone call. This combination is effective because the flyer illustrates the service available and the phone call establishes the personal contact.

Putting together a flyer not only calls on your ability as a calligrapher but requires competence in copywriting and graphic design. As a calligrapher, you may know what you are doing; in your flyer, you must *look like* you know what you are doing.

As mentioned before, you need an opening statement and follow-up discussion. The opening statement is the headline set in a large size at the top of the page (see Fig. 2). The follow-up discussion, or body copy, goes into the details: the cost, styles offered, etc. The graphic design should make as straightforward a "statement" as the copy. Keep it simple, uncluttered, and legible. If you know anyone who writes copy or does graphic design, they might help you out. Perhaps they would barter some calligraphy for their services.

The best approach to selling is to send out a flyer and follow it up with a phone call. The flyer illustrates the service, and the call establishes the personal contact.

Whether you get help with your flyer from someone else or work it out yourself, you might first study the direct-mail pieces that you yourself receive. Some are addressed to your particular needs and you keep them. Others you call "junk mail" and throw out. Begin to analyze the ones you keep. If you are interested in buying the items they advertise, what factors influenced your decision? The way the pieces were designed? The copy? An offering of special savings?

The most important thing to remember as you are putting together your flyer is that the service you are offering should be immediately recognizable to the viewer. Look through any magazine and see how this principle operates in advertisements. Of course you want to attract attention and arouse interest, but above all else, make sure the message is clear.

Now for the production and distribution of your flyer. Even if you do your own writing and designing, a promotion piece will cost you a decent amount of money. The cash outlay goes into paper, envelopes, typesetting, printing, addressing the envelopes, mailing them, and postage. But, if you have more time than money, you can handle many of these operations yourself.

The cost of type and paste-up can be eliminated entirely if you write out the whole piece by hand. This can look perfectly fine and makes sense for your early flyers when there's not too much copy. But if for some reason you feel you need a lot of body copy, consider having it set in type. Type is often a pleasing contrast to examples of calligraphy, it is legible, and it can save you a lot of time. Look up "typesetting" in the Yellow Pages and call around to compare prices; find out who handles small jobs and whether they provide any assistance in layout and paste-up.

Because of the quantities involved, printing is one of the necessary costs. The minimum quantity I recommend for a mailing is 500 pieces. Either offset printing or photocopying may be used; compare them for cost and quality. As a professional, you will need to have jobs printed from time to time, and you should establish relations with a good offset printer. To keep costs down, stick with black ink and whatever paper the printer has in stock. There is no need for him to order special stock at added expense.

You can avoid the cost of envelopes by designing your flyer as a self-mailer. It's just folded up and sent out. Some will doubtless arrive a little crumpled, but the information will be intact.

Envelopes add class and expense. If your flyer is the usual 8½"×11" size, then mail it out in 9"×12" envelopes with a piece of cardboard to keep it from being bent. Write DO NOT BEND in large red letters on the outside. Mailing your promotion piece in an envelope allows you to enclose a cover letter. People like to receive a letter. It's a personal touch, and you can

CALLIGRAPHY

The art of beautiful writing may be used in many ways: addressing envelopes, filling in names on awards and certificates, invitations for weddings and special events, signs, menus, business cards and stationary, poems, prayers, and favorite quotations. ✤ Call to see sample pieces, styles, colors, and for a free estimate.

· Y O U R · N A M E ·
ADDRESS AND PHONE NO.

Fig. 2. This type of flyer might be used by a calligrapher who has become competent in all the skills discussed in this book. Two other flyers, in subsequent chapters, provide examples of what might be used in the first stages of your self-promotion campaign. These are given as models in preparing your own flyers.

use it to request that the piece be forwarded to the right person or posted in the appropriate place.

The Yellow Pages is your most accessible and least expensive source of mailing lists for any category of client. If you do not like the task of addressing 500 envelopes and have the cash, you can hire a typist. However, beginners generally use the least expensive methods even if they take time and effort. Some people address the envelopes in calligraphy to make a good impression. This is one undertaking that I feel requires too much effort for too little gain.

When large companies do mailings, they are very keen to measure their cost effectiveness. You, too, should keep a record of how much you spent and how much business your mailing brought in, but I really would not be concerned with statistics and percentages. You will *know* if you have reasonable success with your first mailing and will be able to make an educated guess as to how the next one might be improved. A mailing is something of an exploration into unknown territory. The main questions you are posing are about the need of your services in a particular market and the acceptability of your work. In addition, you are offering a service, not a product. Do not expect immediate returns. Some people will keep your flyer as long as a couple of years before they have a need for calligraphy. As one marketing executive put it, "As long as you're doing something – *anything* – it helps." If you are not busy with jobs, keep busy with self-promotion.

The follow-up phone call can give you some feedback about the quality of your work and the need in that market. It enables you to ask such questions as: Was the letter received by the right party or received at all? Is that person still with the firm? What was their response to it? Do they use calligraphy? Would they consider using your calligraphy? Would they like to meet you and see your portfolio? Can they refer you to anyone else in the company who might need your work?

What you really want to know is, are they possible clients? (After you read the next section, refer back to these questions and incorporate them into your dialogue.) Make a list of who should receive future follow-ups. Do not expect to open up client relationships with just one mailing. Send friendly reminders from time to time: Christmas cards, perhaps a poem or quotation that is related to their business.

SELLING BY PHONE

If you wanted to sell your car, you might call a friend and say, "Hi. I've decided to sell my car. Interested?" If your friend were interested, you would go into the details: miles per gallon, repair record, condition of the paint, etc.

The object of telephone sales is to convey information in this straightforward, natural manner. It is easy with friends, of course. With strangers, we need to do some preparation. It is a little like preparing a play – you write a script, rehearse it, and act it out until, finally, the presentation is as natural as telling your friend about your car.

The script may be taken from your flyer. Like the flyer, it has two parts: an opening statement (headline) and a follow-up discussion (text). The opening statement, like the headline, should be short and to the point. Suppose the headline on your flyer reads, "Wedding Invitations and Envelopes in Calligraphy." Your opening statement to a client might begin:

"Hello, my name is John Doe. I do wedding invitations and address envelopes in calligraphy. Would you be interested in hearing about my services?"

If they were interested in hearing more, you would go on to discuss charges, the time

needed to complete a job, the color of the ink and paper, etc. Most of this is covered in the text of the flyer.

When you have settled on a "script," the second step is to hear how this written material sounds out loud. Ask a friend to play the prospective client and you play yourself. The client dodges around and you try (politely) to nail him down. He can be negative, evasive, sleepy, or enthusiastically receptive—and you have to match him stride for stride.

Selling by phone is a little like preparing a play—you write a script, rehearse it, and act it out. But there is no verbal formula that will get you through. You have to learn to listen and respond.

Even in rehearsal, you will probably be embarrassed at how awkward your initial delivery is. In a very short time, however, you will find that there are not that many variations possible in this dialogue. Begin to formulate responses that are called for again and again. After a couple of hours, you should be ready for a dress rehearsal, again with your friend, but this time really use the telephone. You will *know* when you are ready for the real thing. If possible, have your friend sit with you through the first couple of hours of actual calling. You may need some encouragement at first as you begin to hear "no" at the other end of the line. Even though you know, logically, that this simply means that they can't use your work right now, rejections are psychologically difficult, especially for the beginner. A little moral support will help you keep dialing until you hear that first, exhilarating *yes*.

Now that you've got your nerve up, let's go back to the specifics of the phone presentation. There are basically two parts to this task: (1) speaking to the person who picks up the phone and (2) speaking to the person who buys or might buy calligraphy. You ask the first person to let you speak to the second person.

You can ask for the second person by name, if your list has names, or by title. How can you find the title of the calligraphy buyer in a given market? Let's say you want to approach churches about wedding invitations. Who in the clerical organization knows about upcoming weddings? If you belong to a church or synagogue or have friends who do, this will be easy to find out. Otherwise, go to a few churches or synagogues and openly ask for advice. In this case, you'll find that it's the priest, minister, rabbi, or his or her secretary that you should contact.

Now you can begin preparing your opening statements for the first person, whoever answers the phone. Keep these statements short and to the point. Then be prepared to respond. For example:

"Hello?"

"Hello, may I speak with the secretary to the minister?"

"Certainly."

Wasn't that easy? And it does happen that way sometimes. Phone calls will never bore you by being repetitious or automatic. There is something different about every one. Here's another variation:

"Hello?"

"Hello, may I speak with the secretary to the minister?"

"About what?"

"I recently sent in a brochure—I do wedding invitations in calligraphy—and I'd like to know if it was received."

You must be prepared to say *who* you are calling and *why* you are calling. Short and to

the point. The rest you have to play by ear.

Be open and direct with this "first person." He or she may be an overworked, minor functionary who doesn't want to be bothered and will say "no" automatically, preventing you from contacting the real decision-maker. That's a possibility. But if they understand your errand, they will probably put you in touch with the right person. There is no verbal formula that will get you through. You have to learn to listen and respond. If you feel the resistance of ignorance, ask for the minister's name so you can send him or her your flyer. More often than not, a no means no. Secretaries generally do know their bosses' needs. Learn to respond courteously; hard feelings will only interfere with the next call and with your whole approach. Respond quickly, too, because it makes sense to get on to the next call.

The two fundamental business questions all beginners face are: "How do I get clients?" and "How much should I charge?"

Suppose the person is too busy to speak with you. "Should I leave my number or call back later?" Suppose they are on vacation. "When do you suggest I call back?" Suppose they already have a calligrapher. "I'd still like to show my work. Someday you may need a backup."

Now let's assume that you do get through to the person you've asked for. In the case of the minister, he would not actually buy your calligraphy, but would recommend it to couples about to be married. Be prepared to answer questions about your credentials and your method of working. How long have you been doing this? How long does it take to complete a job? Do you handle printing, too? Can you supply the envelopes? Calligraphy may be entirely

new to him, in which case you will have to stimulate discussion by asking the right questions yourself. Do all couples ask about such things as invitations or could you get a list of the couples about to be married and approach them directly? Is there a bulletin board that your flyer could be posted on? Are there other uses for calligraphy, such as signs around the church, headlines in the church newsletter, or invitations to other church-related events? Perhaps someone would like a prayer written out beautifully. If you simply inform and inquire—don't pressure—you will usually generate interest.

As you make your calls, keep a log of all the addresses, phone numbers, and names of people. After each call, be sure you have made one of the following notations in your log: B (busy signal); NA (no answer); CB (call back) or CB Mon. 9AM; HWC (he will call); APT (appointment) Wed. 2PM; SL (send letter). Leave nothing to memory. At the beginning of each day's calling, start with follow-ups from this list. Keep after each one until you get a definite yes or no: Be courteous but be persistent. Half a day of calling is enough. Do something enjoyable the other half—like calligraphy.

THE BOTTOM LINE

The two fundamental business questions all beginning entrepreneurs face are: "How do I get clients?" and "How much should I charge?" The preceding sections on selling by mail and phone dealt with the first question. This section deals with the second.

A service does not have a fixed price like a product. When you ask a grocer for the price of a can of beans, he can tell you immediately. When your client asks how much a job is going to cost, you first have to consider the various factors involved in that particular job.

It is vital that you and your client share a clear understanding of the job conditions at the time the price is fixed. Clients are not aware of the factors that affect your working procedures

and it is up to you to ask the right questions and explain your terms. If you leave something unsaid that turns a four-hour job into eight hours, you have just bought yourself a bit of practical experience. Oral agreements are generally fine, but if you feel uneasy about a client, write out a Letter of Agreement including all the specifications. If they sign it, it will have weight in court should a dispute arise. However, more problems arise from lack of clarity than lack of trust.

The price estimate is initially determined by looking at the time conditions, ink and paper, style, quantity, and miscellaneous service charges. Once a job is in progress, the price may be adjusted due to a change in conditions, author's alterations, or cancellation. Let's look at these factors one at a time.

TIME CONDITIONS For the beginner, the main task is learning to estimate how long a job will take. You can prepare for this by addressing envelopes or writing out names as though they were fill-ins on certificates to find out how many you can do in an hour. Envelopes and fill-ins are usually charged by the piece, so if you find you can do twenty-five names an hour and want to earn $10 an hour, charge fifty cents apiece. (I know, that adds up to $12.50. The added $2.50 an hour will pay for set-up and other time spent off the board. This extra margin is important. Do not charge *just* for board time.) When you design your sample invitation or menu, keep track of the time, too. You will probably charge a flat fee for these jobs, so multiply the estimated number of hours by your per-hour rate, add a little extra for safekeeping, and quote the client your price in a cool and confident voice. The only way to prepare for that moment is to play a lot of poker.

Unusual time demands are created by rush jobs. If a client wants the job done "yesterday," and you have to work late hours to complete it, charge extra. A rule of thumb for overtime is to charge one and a half times the normal rate. Rush jobs have several possible consequences: you may have to cancel a social engagement, lose sleep, turn in another job late, or work under pressure for several hours to meet the deadline. There is no way to tell how much this will disrupt your system or your schedule. The added money may not even be worth it, but professionals have to be prepared to do these things.

INK AND PAPER Certain jobs, such as addressing envelopes, fill-ins, and place cards, can be done faster (and therefore cheaper) with a fountain pen. It saves you the motions of dipping and nib-wiping and it facilitates the work flow. But fountain pen ink is less opaque than the ink used in dip pens. In short, the fountain pen saves time but does not produce as pleasing results as the dip pen. This usually does not matter for envelopes, but for fill-ins and place cards, inform the client of the difference in quality and let him decide.

Different papers can affect both your speed and the quality of the end result. Sometimes a very toothy paper will slow you down, but even more irritating are the coated stocks. These are sometimes chosen for certificates. Designed to receive printer's ink from a press, they do not absorb calligrapher's ink, but cause blobs and loss of hairlines. Their slippery surface adversely affects pen handling; writing on these papers is like ice-skating on glass. There are various remedies. The gloss can be dulled with sandarac* or rubbed down with a kneadable eraser. You can also spray the surface with workable fixitive (but do this outside and hold your breath to keep from coating your lungs with plastic). All of these treatments take time.

*Sandarac is a resin, available at some chemical supply stores, which is ground down, put into a cloth sack, and used to powder the surface of paper. Pounce sacks are used in the same way but without the same effectiveness.

When a client says he is supplying the paper, "and it's real parchment," you can bet it's parchment paper, which is a kind of coated stock. It has a mottled, antique look, which is chosen for appearance and certainly not for the convenience of the calligrapher.

"Yes, I know all about that parchment. Terrible stuff to work on. Takes all kinds of preparation to get it working right, and I'm afraid I'll have to charge extra."

Before you commit to a price, test the paper. If you have to give a quote without seeing it, stipulate that the quote is based on good stock.

It is vital that you and your client share a clear understanding of the job conditions at the time the price is fixed. More problems arise from lack of clarity than from lack of trust.

STYLE Different hands have an effect on time: italic is fast, blackletter and Spencerian are slow. When given the choice between the less expensive faster hand and the more costly slower hand, most clients choose the former. You get pretty good at italic.

ADDITIONAL COSTS Production costs for most jobs will be minimal or nonexistent, but do be sure to add them onto the bill as they arise. If you are preparing art for printing, a common production cost will be for photostats. You may sometimes be asked for a special item, like a ribbon to weave into a certificate, which does not cost much but does require extra time to locate. Charge for this time as you would for time at the board.

If you choose to offer personal pickup and delivery service to clients, the time you spend traveling should be figured into the bill. If you hire a messenger, itemize his fee as a service charge. For a first job, clients will often ask that you make the initial pickup personally so they may meet you, see your work, and discuss the details of the project. That makes sense. It makes equal sense for clients to pick up the completed job and proofread it at your studio. That way, if they catch an error, the correction can be made on the spot. But if they want you to deliver the finished product, do so and charge for it. Some clients assume free pickup and delivery is part of the service; you can avoid any awkwardness by bringing the subject up when you are nailing down the other job conditions.

MINIMUM CHARGES Suppose you ordinarily charge a dollar to fill in a name on a certificate. That rate works when you have enough certificates to turn them out on an assembly-line basis. But suppose someone asks you to do five certificates. You have to spend time on the phone getting the job, possibly picking up the certificates—then there's set-up time, proofing, writing a bill, making an entry in your books, and, if there's a mistake, making the correction free of charge. All of this is worth more than $5, so you have to establish a minimum rate. The same principle applies if you are working on a large job and the client begins sending you additional batches of three or four names (because of errors or poor planning on his part). Ask him to let the additions accumulate to a significant number. If this is not possible, quote him your minimum rate, although it can be a bit lower than usual because you are familiar with the operation.

CHANGE OF CONDITIONS Conditions may change during the course of a job owing to any number of unexpected circum-

stances. There is nothing wrong with this so long as your client clearly understands that when the original job conditions change, so does the original price. The beginner, eager to land work, is likely to accept a sudden request for rush work, or a change in the materials agreed on, without attempting to make a corresponding adjustment in the charges. Learn to react quickly and professionally when a client asks for something that adds to your workload.

Sometimes you will have to point out the added charge immediately and sometimes you simply tack it onto the bill. Other times, the client may have to accept a lower quality in the finished product. Suppose the paper supplied by the client turns out to be coated stock when you were expecting uncoated. In that case, give the client a choice: Does he want to pay for the extra time needed to prepare the paper, or will he accept the slightly inferior quality that comes from using unprepared coated stock?

Depending on his nature, the beginner is often too reticent or too peremptory when it comes to asking for more money. But once you become comfortable using the terms introduced in this chapter—rush, overtime, AA's, cancellation fee, etc.—you can give special requests a "name" and explain how they are routinely handled in your profession.

AUTHOR'S ALTERATIONS Known as "AA's," author's alterations refer to corrections that have to be made due to an error in the original copy or because the client changed

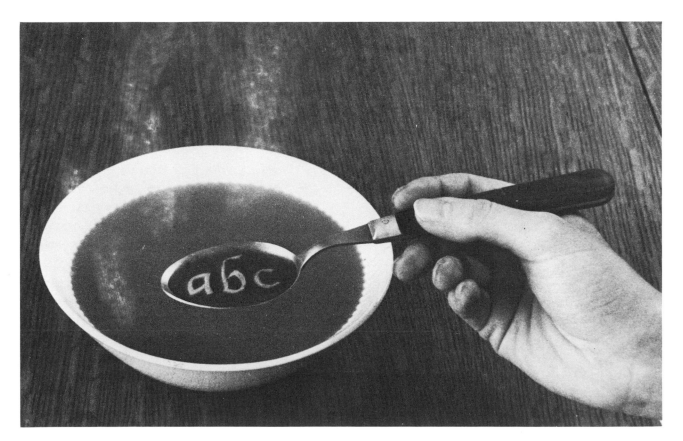

Fig. 3. This photograph of calligraphic alphabet soup was used in a promotional brochure sent to art directors in advertising agencies and design studios. The letters were cut from water-softened macaroni with an x-acto knife.

his mind about the wording or style after the work was started. AA's are common and you should learn to accept them with an air of solicitude and an added charge on the bill.

CANCELLATION FEE If, through no fault of yours, the client halts a job after you have done some work on it, you are entitled to a cancellation or kill fee. Estimate what proportion of the job has been completed and ask for that proportion of the total price. If you complete the job and the client does not like the quality of the work—and if the quality is the same as the samples you showed before the job—he should pay you for what you've done. If your work is not satisfactory, you should be the first to admit it. If it *is* good, do not be intimidated. There are some professional bullies who can convince almost any artist that his work is worthless and he doesn't deserve two cents for it. In such situations you often hear the phrase, "This is not professional work!" Don't fall for this line. Even if you do not have anything in writing, march down to Small Claims Court and settle the dispute before an impartial third party.

For the beginner the main task is learning to estimate how long a job will take. But remember, when the original job conditions change, so does the original price.

Beginners are often tempted to take jobs for little or no money "for the experience." If your work is not good enough to charge for it, practice on your time, not the client's. If it is good enough, do not work on speculation, that is, getting paid only if the client approves of the work. The time spent on speculation work is better spent on private practice or digging up work. The time will come—and this is really the moral of this section—when you will recognize and resist proposals from businessmen in love with their money to artists in love with their work.

PROOFREADING AND CORRECTIONS Any errors in a job that are your fault should be corrected free of charge. Although you should look over every job carefully, it is difficult to proofread your own work. The same mistake you made in writing is likely to be overlooked in reading. Ideally, the client should proof the work in your studio so corrections can be made immediately. Otherwise, enlist the help of a friend or colleague. No matter how beautiful a certificate may be, the person who is being honored will not be pleased if his name is spelled wrong. Learn how to accept responsibility graciously; do not force a client to say, "We can't pay for it this way."

COLLECTIONS When you and the client have determined the conditions and cost of a job, be sure to ask one more pertinent question: "How long do you folks take in paying?"

A month is the ordinary waiting period for payment. Calligraphers do not have cash-flow problems—we do not have to lay out large amounts for supplies and wait in suspense for accounts receivable to make up the difference—but it is irritating when a client is slow in paying. A gentle reminder by phone is usually effective. While I never believe the computer-snafu stories, some companies do experience accounting snags and you have to be patient.

I use the following system for keeping track of past accounts. It lets me know at a glance who owes me money and who needs a nudge.

Date	Company	Job	Amount	$	Art
4/7	Carlyle	"Our Past"	$225	✓	
4/12	A&R	50 certs.	$135	✓	✓
4/18	Dean	menu	$450		

The entry is made when both job and bill have been delivered. (I generally send them both off together.) A check in the dollar-sign column means payment has been received. A check in the "Art" column means a sample of the printed piece (such as an invitation or a menu) has been received.

Once in a while you get a real deadbeat and have to go to Small Claims Court. The cost and paperwork are minimal. When the court notifies your client of the hearing date, that might sting him into recognizing your existence and often you will get paid without further ado. If they call to dispute your bill, at least you have achieved communication. If you have your day in court and tell the truth, you will probably leave with renewed respect for our legal system.

A traditional English design, white lettering on terracotta. The trick is to pattern the flourishes evenly around the words.

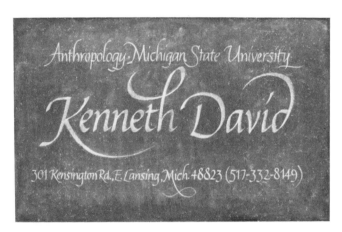

A special card for my brother, an anthropology professor, written out on a blackboard.

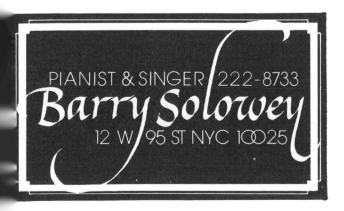

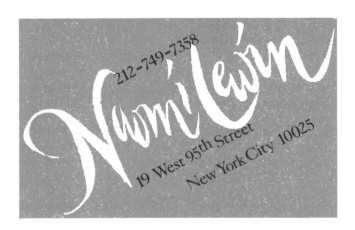

A modern look with lettering and type. A marker was used for Naomi Lewin's card.

Getting Started

Addressing Envelopes

This is the kind of work you are in a position to get right away. The skill level and equipment requirements are modest and the sources of jobs easy to identify and approach. Addressing envelopes gives you practice while building confidence for the more challenging projects to come.

MATERIALS Fountain pen (start with one pen and a #3 or #4 nib; later, you may want to have a few pens handy with #2, #3, and #4 nibs). Fountain pen ink (most of these jobs call for black ink; if a different color is requested, it is simple enough to wash out your pen and reload it). Light box. Ruling pen or technical pen for guidelines. X-acto type knife and card stock (for template method).

SPECIFICATIONS Before giving an estimate, ask the following questions: How many envelopes are to be addressed? Are the ad-

dresses three lines or four lines? (Four-line addresses take more time to do and should cost more. Often a list will include both three- and four-line addresses, but you can give a quote based on three lines with the understanding that, after the final tally of three- and four-line addresses is made, the price will be adjusted accordingly.) What color ink and what style calligraphy is desired? (Most people choose italic

Addressing envelopes gives you practice while building confidence for the more challenging projects to come.

in black.) Will the list of addresses be typewritten or in legible handwriting? (If you have to puzzle over a sloppy or illegible list, it adds time to the job.) Will they supply the envelopes or should you buy them? (If you buy them, charge for the time you spend shopping as well as for

the cost of the envelopes. Most envelopes are designed to receive handwritten addresses. You should not have any difficulty with the paper surface or need to test them before giving a quote.) Will the return address be printed on the envelope (which is the common practice) or are you to do that as well?

PROCEDURE Look through the whole list of names and addresses and select a few of the longest lines (Fig. 1). Write these out with the #3 or #4 nib to see if they fit and how they look on the size of envelope you are using. (This will also show you how the ink takes to the envelope paper.) If the letter size looks good but a few of the longest lines do not fit, these can be condensed.

On tracing paper, draw ink guidelines for the nib size you have chosen, and draw right- and left-hand margins. Hold the tracing paper over an envelope to center the guidelines between the top and bottom and to center the margins between the sides. Then draw the outline of the envelope on the tracing paper. Fig. 3 shows the tracing paper with the guidelines, margins, and outline of the envelope. A strip of cardboard has been taped along the bottom

edge of the outline of the envelope. This acts as a shelf on which you can line up the envelopes with the guidelines in an assembly-line fashion.

Tape the tracing paper onto the light box. As the ink guidelines have to show through two layers of paper (the front and back of the envelope), work in a dark room. Some envelope stock is quite heavy, and you may have to rule thicker guidelines than usual.

If the envelopes have an inner lining of decorative paper, which precludes the use of the light box, or if you do not have a light box, there is an alternative method of lining up the addresses. Using the guidelines, margins, and outline of the envelope on the tracing paper, cut a piece of card stock to the outer dimensions of the envelope and cut little windows

Fig. 2. Above, a #3 nib. Below, a #4 nib (reduced).

Mr. and Mrs. Thomas Ribblesdale
2106 Chestnut Way
Philadelphia, Pa. 19103

Fig. 1

Mr. and Mrs. Thomas Ribblesdale
Mr. and Mrs. Thomas Ribblesdale
Mr. and Mrs. Thomas Ribblesdale

Mr. and Mrs. Thomas Ribblesdale
2106 Chestnut Way
Philadelphia, Pa. 19103

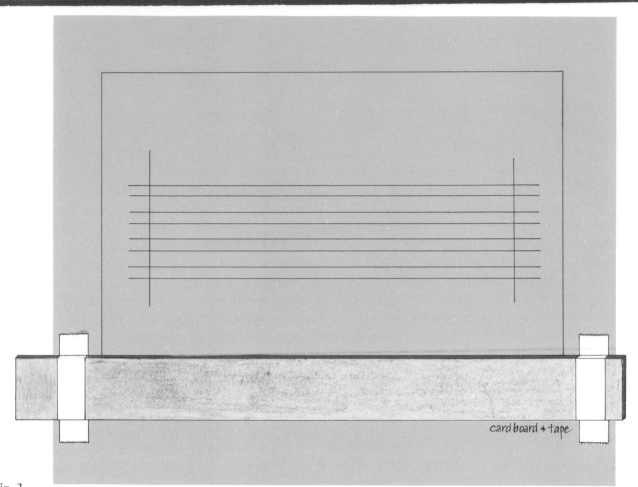

card board & tape

Fig. 3

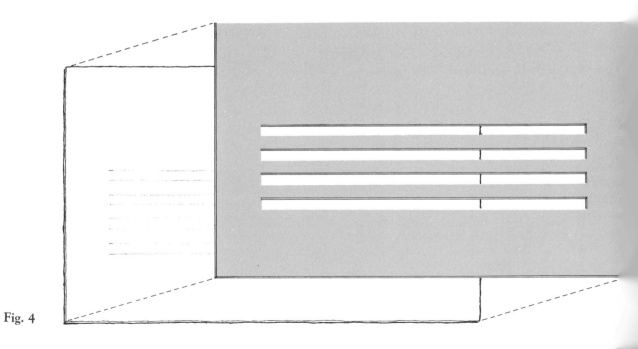

Fig. 4

within the x-height lines and the margins (Fig. 4). Place this template over each envelope and lightly pencil in the guidelines. Use a soft pencil (like HB) which can easily be erased after the ink dries.

The return address is ordinarily printed on the envelope in the upper left-hand corner or on the back flap. If you are asked to do return addresses by hand, draw additional guidelines on the tracing paper and use a #4 nib size. And remember to charge additionally for return ad-dresses. Whatever adds to your time adds to their cost.

SOURCES OF WORK Most people prefer to send hand-addressed invitations to special events such as weddings, parties, dinners, and bar mitzvahs. Contact the places that sponsor or supply these events: bridal shops, churches and synagogues, caterers, country clubs, and social organizations.

his flyer demonstrates a simple and effective esign approach for the beginner. The message clear as to the type of service and the quality the work. You may adapt it, either for copy or yout, for your own flyer. To see how this ould look on an 8½" × 11" page, enlarge it (by aking a photostat) by 170 percent.

Envelopes Addressed in Calligraphy

Mr. and Mrs. J. Doe
123 Main Street
Hometown, U.S.A

Weddings, Parties, Dinners, Bar Mitzvahs.
Italic style as shown.
$() apiece for standard 3 line envelopes.
$() minimum. Extra lines () ¢
Black & brown ink. Other colors $().

YOUR NAME & PHONE NO.

The Bread-and-Butter Job

More money is made by filling in certificates and pre-printed invitations than by any other use of calligraphy. Indeed, you may find that this kind of work will become the staple of your professional existence.

MATERIALS Fountain pen or dip pen, depending on what paper stock is used and/or the desired quality of the lettering. You may prepare coated paper stock by rubbing it with sandarac or taking off the shine with a kneaded or white eraser. You may also spray the paper with workable fixative. Stick ink, gouache, or poster paint work best over coated stock. Red marker for center lines.

SPECIFICATIONS How many certificates or invitations are there? What type of paper are they printed on? (Certificates are often printed on paper that makes lettering difficult.

If possible, get a sample before giving a quote. If you cannot, ask if the paper has a glossy or matte finish and give a quote based on your guess of the paper quality, with the understanding that if the quality turns out to be radically different, the price will change accordingly.) How much information is required on each one (name, company, date, etc.)? Black ink or color? (Sometimes two colors are requested. For instance, the name may be done in large red letters while other information is written smaller and in black.) Will the lettering all be one size? (Switching between different nib sizes adds time to the operation.) What style of lettering is requested? Finally, if you're filling in certificates, make sure the client sends many extras. If you have to get fifteen names letter-perfect on fifteen certificates, the double- and triple-checking for accuracy before the actual inking may double your time, and their cost. It's usually more efficient just to re-do certificates with errors.

PROCEDURE Party invitations are the simplest fill-in job. These printed pieces usually read something like:

You are invited to:_____
Date:_____
Time: _____
Address: _____
R.S.V.P. Please call_____
before _____

They are easy because you just fill in the information on the appropriate line. There is no decision-making, and no centering.

On most certificates, the information has to be centered on a line. How do you look at a typewritten name and know where to begin writing it so that it is centered on the certificate? There comes a time when you will know just by looking (and this procedure is described later on), but there are easier methods with which to start.

All methods begin by choosing the appropriate letter height and nib width. Hold tracing paper over a certificate and, in pencil, write out a few of the longest and shortest names from the list in an x-height that looks right to you. Experiment with different sizes. One will *look* right (Fig. 1). Choose the nib(s) appropriate to that x-height (five nib widths equals the x-height), as well as one that is a half-size smaller and one that is a half-size larger. Test all three sizes on tracing paper (Fig. 2), then hold them over the certificate. When you are finally happy with a nib size, try it out on a certificate. This will also give you a feel for the paper surface.

As a beginner, you will get the best results by writing out all the names on another piece of paper before filling in the certificates. This way you can see exactly how long each name is and can center each one exactly. It is also a good warm-up exercise that develops fluidity in your stroke before you start the actual work. If you do not need the warm-up, you can save

How do you look at a typewritten name and know where to begin writing it so that it is centered on the certificate?

Fig. 1

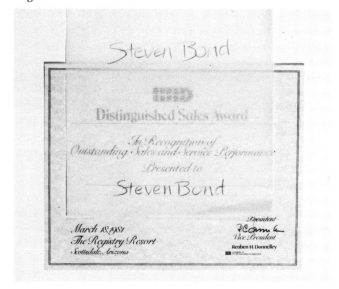

Fig. 2

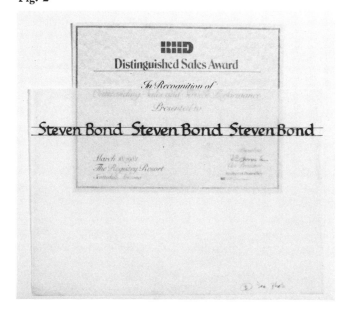

time by writing the names out in pencil or roughly in ink. This is called "comping in" letters. These letters may be roughly and quickly drawn but must be spaced identically to your finished letters. After comping in about ten names, write out a few finished names to see if the spacing is the same (Fig. 3). Find the center of each name and mark it with a red dot just above the letters (Fig. 4).

Andrew Perlik
Eugene Pompei
Pat Scanni
3¾"

Andrew Perlik
Eugene Pompei
Pat Scanni
3¾"

Fig. 3

Janis Stern
Franklin Werth

Fig. 4

Draw up a guideline sheet according to the method described in the chapter on envelopes. Draw a red vertical line down the center of the guidelines. Tape the guideline sheet to the light box. Position a certificate over it. Hold the comped name up to the space, aligning the red dot with the red vertical line. Look at where the name is positioned in relation to the printing on the certificate. In Fig. 2, the "S" of "Steven" falls under the "n" of "Outstanding". This, then, is the starting point.

If a job calls for utmost accuracy of position, write out all of the names in finished form, put red dots over their centers, position each name over the guideline sheet, put the certificate in place, and *trace* the name onto the certificate. This degree of perfection is rarely called for, but it's an interesting exercise as it allows you to make subtle corrections in letter forms and spacing while you trace over your own work.

Writing out all the names is a good method for the beginner, as a warm-up exercise, for short jobs of a couple of dozen names, or for jobs requiring exact centering. But if you are filling in a couple of hundred names, there is another method for approximate centering which takes much less time. After the initial preparations, it will allow you to look at the typed list

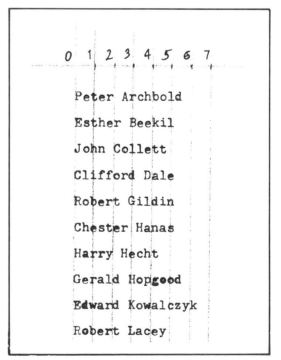

0 1 2 3 4 5 6 7

Peter Archbold

Esther Beekil

John Collett

Clifford Dale

Robert Gildin

Chester Hanas

Harry Hecht

Gerald Hopgood

Edward Kowalczyk

Robert Lacey

Fig. 5

Tracing over your work on a light box allows you to make subtle corrections in letter forms and spacing.

and know where to start the written name on the certificate.

First, determine the letter height and nib size in the same way described earlier. Comp out ten names from the list (including the longest and shortest names). Put this aside for the time being. Tape the list of typed names on your drawing board (lining up the bottom of the typed line with the T square) and draw vertical pencil lines through the names at quarter-inch intervals. Number these lines (Fig. 5).

Follow the course of the vertical pencil line #1 through the typed names. It falls through the "t" in Peter, the "t" in Esther, the "h" in John, and so forth. On the list of comped names, put a red dot over these letters. Mark the position of all the other vertical lines on the comped names as well (Fig. 6). The dots do not fall in perfect vertical alignment with each other, but they do allow you to determine approximately where the vertical lines should fall through the comped names. Keep the intervals between these lines equal (Fig. 7).

Draw up the guideline sheet as follows: Tape tracing paper over a certificate. Draw trim lines (the outer edges of the certificate), roughly indicate major elements on the page such as the logo and the largest type, and draw guidelines for the x-height you have chosen (Fig. 8). In this illustration, vertical axis lines have been added as the names are to be written in a humanist hand. For italic or Spencerian script, of course, slanted axis lines would have been drawn. Draw a vertical line down the center of the guidelines. To the right and to the

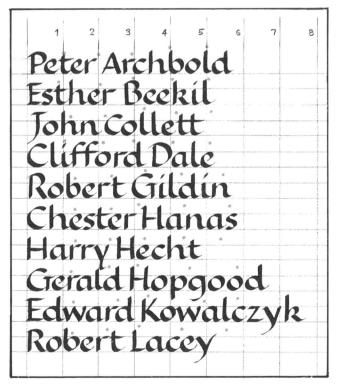

Fig. 6

Fig. 7

left of this center line, mark off numbered intervals that are *half* the size of the intervals on the page of comped names. In this example, only the numbered intervals 4 to 8 have been marked off since no name is shorter than 4 or longer than 8.

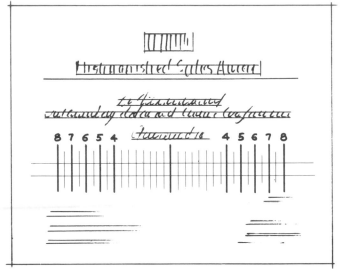

Fig. 8

Pick a name from the comped list—we'll use Robert Gildin. It finishes between lines 5 and 6. Put the certificate over the guideline sheet (on the light box) and start Robert Gildin between 5 and 6 on the left. If everything is working, the name should end between 5 and 6 on the right. If it does not, cheat a little. Add a flourish to the right or left to balance things out (Fig. 9). Once you have correctly set up the numbered intervals on your guideline sheet,

Una Keene
Andrew Pais
John Collett

Fig. 9

you can center names on the certificate by working directly from the numbered intervals on the typed sheet.

When you have done hundreds of names in the same style and nib size (for instance, italic with a #2 nib), you will get a feel for the length of the written name just by looking at the typed name. Write out a few finished names. (At this stage it should take only three names to warm up.) With guidelines, axis lines, and certificate in place, hold the first name up to the space and center it by eye in relationship to the printed line over the space. (For instance, in Fig. 2 the way "Steven Bond" relates to "Presented to".) Make a mental note of where to start the name (the "S" of "Steven" falls beneath the "n" of "outstanding") and write it out. If it is centered, see how the next typed name relates to the length of the first one. If it is the same length, use the same starting point.

A good typist can do sixty words per minute. You'll be riding high when you can turn out two words per minute.

If it is longer, start further to the left. If it is shorter, start further to the right. If the first name was not centered, make the appropriate adjustment with the next name. This method requires visual estimation all down the line and would probably tax the beginner and distract his attention from his letterforms, so hold off on this approach until you've gained some experience.

The reason you have to go to all this trouble, of course, is that the spacing of typed characters is not the same as the letter spacing of calligraphic characters. In typewritten copy, the words "bill" and "boom" have equal lengths. For the calligrapher, "ill" are narrow characters

and "oom" are wide characters, and "boom" is written out longer than "bill." But after you have done enough certificates, you learn to fudge these differences with flourishes. If a name comes out very off-center, do it over. You will find, eventually, that it's faster to risk having to do a certificate over once in a while than to painstakingly center each name.

When you're ready to go into production, tape a strip of cardboard onto your drawing board and slip the typed list under it. Slide it up to reveal one name at a time. This will save you from hunting through the list each time to find your place.

Keep track of how many certificates you can do per hour so you can better estimate future jobs. A good typist can do sixty words per minute. You'll be riding high when you can turn out two words per minute.

SOURCES OF WORK The big certificate jobs come from schools and corporations, but it may be premature for the beginner to approach these places. At first, try contacting printers, design studios, and advanced calligraphers who often farm out work of this type to their less-experienced colleagues.

It is not worthwhile advertising this skill alone on a flyer. Instead, add "Names Filled in on Certificates, Awards, and Invitations" to your flyer on addressing envelopes.

For an Oriental Evening, bamboo was drawn in green ink with free pen manipulation and the names were done in brown.

Some occasions call for special decoration. For a French Dinner, the fleur-de-lis was rubber-stamped in red and the names written in blue. The fleur-de-lis was cut from an ordinary eraser with an x-acto knife.

For a gala dance the cards were sprayed in light blue (with Krylon spray paint) and then misted in lavender. The stars were sprayed in gold through a hand-cut stencil, and the names were written in navy.

Place cards for table settings or name cards which are worn at conventions often have the company logo or imprint. A place card requires heavier stock than a name card because it must generally stand on its own in a tent fold. Paper stock for name cards may be purchased at a stationery store, along with the protective plastic sleeves and pin attachments.

Fig. 14

The Child Welfare League of America is pleased to present this certificate in recognition of the contribution of time, effort, and ability of

Anthony Logan

in serving as Hospitality Chairperson for the '77 CWLA Regional Conference held in Indianapolis, Ind.

Executive Director

President

Fig. 15

Mr. and Mrs. Gerard Piel
cordially invite

Mr. Ross Conley

to a dinner honoring
Frau Ruth Katzenstein and Herrn Gustav Schoser
charter subscribers to SPEKTRUM der Wissenschaft
Tuesday evening, the first of May, at six o'clock
at the New York Botanical Garden Conservatory

R.S.V.P. 754-1873

Your calligraphic fill-in will blend into a certificate better if you also do the certificate. Compare Figs. 14 and 16, which are completed by the same hand, with 15, which is set in type. In the examples shown here, the conservative (16) and the expressive (14), the names stand out from the text because of their color, not because of increased size or a change in style.

HAVERFORD COLLEGE

This certifies that
Stephen G. Buyske
has been selected as a Charles A. Dana Scholar
at Haverford College
in recognition of good character,
academic promise and leadership ability.

Fig. 17

Fig. 16

If you make a mistake filling in a name on a certificate, you can throw it away. Not so with a book dedication (17); there is only one way to do this kind of job—very carefully.

Elementary Design

S ign painting is a craft of its own. Father Edward Catich, famous for his studies of the inscription on the Trajan Column, once said that the Chicago sign painters in the 1930s and 1940s were as skilled in their brush technique as the ancient Romans who did the preliminary brushwork for the stone carvers. As your appreciation of letterforms develops and you begin noticing signs in your neighborhood, you will undoubtedly begin to identify craft in work you had always taken for granted. If you really get hooked, you won't be able to see the words for the letters.

MATERIALS Almost any kind of paper is appropriate for small signs that will be taped up on walls or windows. Large signs require special paper, especially if you use a very broad nib (one-half inch or wider) that leaves a wide track of ink and enough fluid to pucker the paper. Sign supply shops sell poster paper in various weights that withstands moisture puckering yet is transparent enough to be used on a

light box. These shops also sell poster board, which comes in many weights, is clay-coated, and cannot be used with a light box. Other types of board include railroad board and illustration board, both of which are carried in art supply stores. You must use some kind of board for easel signs that stand up on table or counter tops. Boards and paper come in various colors. Dip pens, broad-nibbed pens, and chisel markers may all be used. The barrels on markers are larger than pen barrels and require a little adjustment in handling. The broad nibs take no adjustment—and it's quite a thrill the first time you stripe the page with strokes one inch wide. Gouache and poster paint are preferable to colored ink, which is transparent and not as legible on a large scale. Double-stick tape (with adhesive on both sides) is useful for affixing wall signs.

SPECIFICATIONS If it is possible, you should visit the location where the sign will be displayed to get an idea of its context, but it is

possible to get the basic information over the phone. How big should the sign be? Should the letters be all capitals or upper and lower case, and how high should they be? (The client may let you make this decision, but do find out from him which elements of the message he wants emphasized.) Does the client want colored paper or ink, or a border design? Will the sign lie flat, be taped up, or be free-standing? You need to know this in order to decide whether to use paper or board.

PROCEDURE The way you approach a sign project depends mostly on size—the size of the letters and the size of the sign. This is determined by function and available space. The function of some signs is to attract attention (SALE TODAY ONLY), while others are meant to recede into the background until you need them (MEN'S ROOM). Still others can

be as small as a caption next to a photograph that forms part of a display.

The size of a sign is determined by function and available space.

If possible, take a sketch pad to the location and rough out the sign to approximate size. To start the layout, roughly indicate the lettering with rectangles (Fig. 1). Then sketch in the letters, but do not use guidelines or neat letterforms (Fig. 2). Your only concern should be whether the viewer can read the message from the distance he is most likely to be from the sign. Tape the rough-up in position. Stand back and look at it with the whole setting in view (Fig. 3).

Back at the drawing board (Fig. 4) deter-

Fig. 1

Fig. 2

Fig. 3

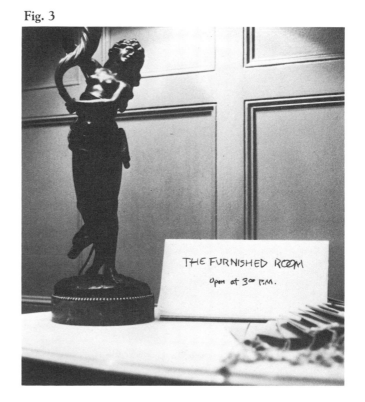

mine x-height and line spacing, then comp in the calligraphy (Fig. 5). After making the appropriate adjustments, you're ready to do the finished calligraphy (Fig. 6).

Border lines are often an important element for framing or drawing attention to a message (Fig. 9.) Look at the signs in your neighborhood and notice the way these lines are used for emphasis and ornamentation. Tape made of fabric or plastic can be used for precise

Fig. 4

THE FURNISHED ROOM
Open at 3⁰⁰ P.M.

Fig. 5

THE FURNISHED ROOM
Open at 3⁰⁰ P.M.

Fig. 6

THE FURNISHED ROOM
Open at 3⁰⁰ P.M.

At first glance, the comp does not look much different from the finished piece. However, a careful comparison of the two, letter by letter, will reveal the subtle differences in detail that distinguish good letter form.

The layman says, "I can't even draw a straight line." The artist knows that drawing a clean, straight line takes some doing.

borders. Markers, which come in many colors, are good tools for making border lines, and with some practice, you can learn to use these as well as pens along a straightedge. How quickly you move the pen depends on how the fluid is taking to the surface. Draw too fast over a toothy surface and the line will be ragged. Draw too slowly over a glossy surface and the ink will blob. The layman says, "I can't even draw a straight line." The artist knows that drawing a clean, straight line takes some doing.

Fig. 7

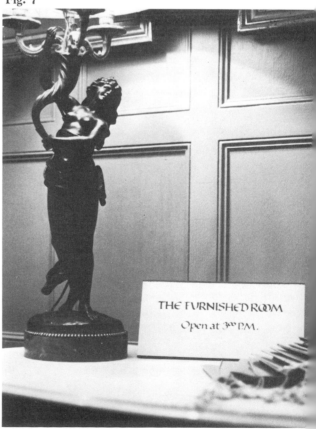

SOURCE OF WORK Before you go into business as a sign maker, do some market research. This means going to the markets in your neighborhood and looking at the way signs are used. You will find a wide range, from expensive fabrications in metal and plastic to paper counter cards. Outdoor signs are engineered to withstand the elements, but most indoor signs are made with materials that are familiar to you. Pick out a counter card and a paper window sign that could be improved if they were executed in calligraphy and work up your sample pieces. When you call on the managers of local shops to show them your samples, be prepared to suggest uses for calligraphic signs that will present their merchandise in a new and exciting manner.

Fig. 8. Stand-up easels require sturdy board stock. You can letter directly on illustration board or on paper which can then be pasted on to the board. Determine the size of the easel in its unfolded position and pencil the dimensions on the board. Cut the outline with a mat knife and score lightly along the fold lines. Some easels will need a reinforcement strip pasted on to the main panel.

Fig. 9. The placement and weight of border lines should be decided in the comp stages, along with the calligraphy. Above, left: pencil guidelines are drawn to determine the length of and the distance between the border lines. Above, right: the thick line is drawn along a straight edge with a broad-nibbed pen or marker, which will leave the ends of the line squared off. Right: the thin line is drawn with a ruling pen.

This sign was used for meetings in the early days of the Society of Scribes.

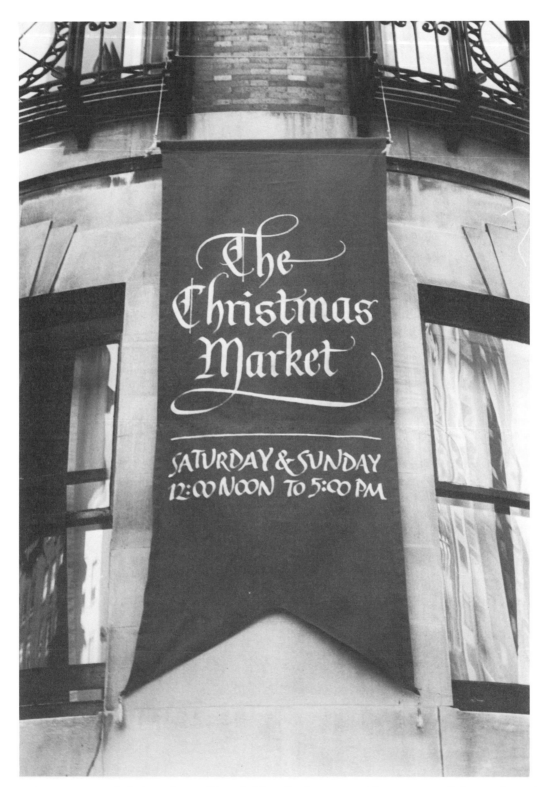

White acrylic paint on red cloth with a stiff brush. Usually these materials are not used for outdoor signs.

Ink on unprimed wood with a Coits pen. Hung in a Zen garden, this sign was expected to show the weathering effects of time and the elements.

Preparing a Mechanical

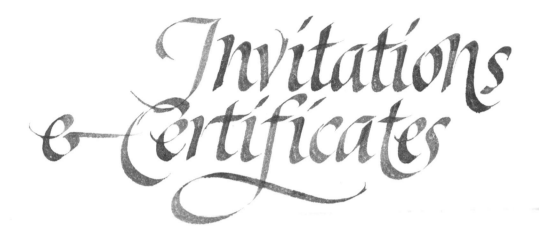

Invitations & Certificates

This chapter is an introduction to preparing art for reproduction. Hand-addressed envelopes, fill-ins, and signs are called "original art." That is, the ink and paper used by the calligrapher are the same ink and paper seen by the viewer. Art for reproduction, on the other hand, is turned over to a printer, and it is his ink and paper the viewer sees. We mentioned invitations and certificates earlier as fill-in jobs, in which you simply write in information or a name on a pre-printed form. Fancier invitations, such as those for weddings, are usually written out entirely in calligraphy and then reproduced by a printer. The same is true of certificates, on which only the name of the recipient is filled in by hand.

Art is submitted for reproduction in the form of a "mechanical," and we will discuss the procedure for making a simple mechanical in this chapter. If you have not yet taken a course in mechanical art or read about preparing art for reproduction, now is the time.

Whether you are designing an invitation or a certificate, the method for preparing a mechanical is essentially the same. For purposes of this chapter, then, we will look at the step-by-step process of creating a wedding invitation. Once you have mastered the principles, you will be able to appy them to certificates as well.

MATERIALS Fountain pen or dip pen; any deep black ink (a transparent black can cause difficulties in the reproduction process); any paper you are comfortable using (expensive or inexpensive); non-repro blue pen or pencil; X-acto knife or single-edge razor blade; steel straightedge; T square and triangle; one-coat rubber cement; a piece of linoleum, or chip board completely covered with masking tape, for a cutting board.

SPECIFICATIONS Wedding invitations most often come as a five-piece set: (1) the outer envelope, which is addressed by hand and has

a return address printed on it, (2) an inner envelope with the name of the guest written by hand and containing the invitation, (3) the printed invitation, (4) a printed RSVP card, and (5) an inner envelope for returning the RSVP card with an address printed on its front. Sometimes, there is another enclosure giving transportation directions. If you are asked to do an invitation, find out about the other components. When all the pieces are done in the same hand, it unifies the presentation. All of them can be printed except for the hand addressing of the outer envelope and the inner envelope.

People in the trade can be good teachers. After all, they want your business.

Will the client buy the paper stock and coordinate with the printer, or do they want you to do this? If they are handling it, find out the sizes of all the pieces on which you will be working. If it is your responsibility, ask what color paper and ink and what style calligraphy they prefer. Request that they type out the text for the invitation. Are there any names or phrases in the text they would like emphasized?

Locate a printer who handles invitations. (Do this now, before a job presents itself.) Printers have different specialties, and it may take some searching. If you can, request samples of the paper and envelopes the printer regularly stocks. Learn his requirements for preparing the artwork. People in the trade can be good teachers. After all, they want your business.

If you are handling the job from beginning to end, then the printer has no contact with your client. He gets his instructions from you and is paid by you. You have the responsibility for seeing that his work satisfies your client's

requirements. Experience will teach you to translate client language into printer language (a great help to both parties). When you charge your client for printing, it is customary to mark up the printer's bill by 20%.

PROCEDURE Invitations are traditionally centered on a card about 5"×7". If you want a rough idea of how the shape of the text looks on the card, make a pencil sketch to size. Pencil sketching is a great loosening-up exercise; it can ease you into a job. There is kind of a calligrapher's cramp that can set in at the beginning of jobs, a feeling that the hand is not steady. Some people warm up with "arcade" (e.g., continuous looping n's or u's) and "necklace" (e.g., abacad or any letter inserted throughout the alphabet) exercises; I use the pencil sketch.

Make up a set of guidelines for any nib size that is comfortable for you. Your work will be reduced when it is printed, so you can work at almost any size. When drawing guidelines for the x-height, it is important to leave enough line space so the descenders of one line do not overlap the ascenders of the line below it. If you normally draw your ascenders and descenders three nib widths beyond the guidelines, then leave seven nib widths of line space. The guidelines and axis lines may be drawn with non-repro blue pencil directly on the paper you will use for the finished art. This method does not require the use of a light box. Another method that does use a light box will be described later.

On your guideline sheet, write out the finished calligraphy, beginning each line at the left margin. Measure each line and mark its center with a non-repro *blue* dot.

Choose a piece of illustration board that allows for at least a three-inch margin around

the text. Draw a vertical line down the center of this board in non-repro blue.

Put a light coat of one-coat rubber cement on the back of the text. When the rubber cement dries, lay the paper, cement side down, on the linoleum cutting board. Mount the cutting board on your drawing board, line up the calligraphy horizontally with the T square, and tape the cutting board in place. With a metal straightedge on top of the T square (to protect its plastic edge), cut the text lines apart with an X-acto knife. These straight horizontal cuts can be made only if the ascenders and descenders do not overlap (Fig. 1).

Fig. 1

The honor of your presence
is requested
at the marriage of
DEBRA ANGEL
and
HENRY WRIGHT
on Sunday
the seventeenth of May
three o'clock
at Grace Church
*64*th *and Vine Street*
New City

Remove the cutting board from the drawing board. Tape down the illustration board after lining up its vertical blue line at 90°. Lift off the top strip of paper from the linoleum.

With the T square, line up the calligraphy perpendicularly to the vertical blue line and position the blue center dot on the blue line of the illustration board. Add the other strips of paper one by one, keeping the blue dots on the blue line. If you butt the top edge of each new strip with the bottom edge of the last strip, you won't need the T square to keep them parallel (Fig. 2).

Fig. 2

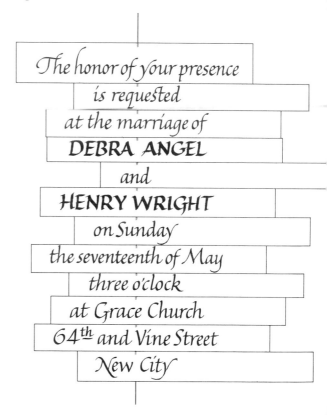

Another method of centering the text lines makes use of the light box. Here, you do not need to leave extra line spacing; the ascenders and descenders may overlap.

Draw ink guidelines and axis lines on tracing paper. Then, with bond paper over the guidelines on the light box, write out the first draft of the text with a flush-left margin. Measure the lines and put a red dot above the center of each. On another sheet of tracing paper,

draw a horizontal i[nk line]
through the center o[f ...]
dicular to it, a red ver[tical]
izontal ink line with[...]
and tape both shee[ts ...]
sheet of bond pape[r ...] g-
raphy to the light b[...] ee
taped-together she[ets ...] ing
up the red vertic[al ...] ver
the center of the[...] lines

*Experien[ce will teach yo]u to
translate [calligraphy] into
printer l[...]*

horizontally[...] ace the top
line of the[...] ne the letter
shapes and[...] o the right or
left, adjus[...] rs and words.
Center a[...] the text in the
same wa[...] aft is completed,
you ma[...] draft on top of it
and ref[...] er.

In [...] envelopes, we ar-
range[...] e border size. Now
we w[...] und the words. The
followin[g ...] ow how to draw bor-
ders in direct pro[p ...] to the trim size of the

invitation and which the printer will be able to reduce accordingly.

In the lower left-hand corner of a piece of tracing paper, pencil in points for the four corners of a rectangle to the measurements of the actual invitation. You may even trace around one of the cards it will be printed on (Fig. 3). Draw a diagonal from the lower left-hand point through the upper right-hand point and extending into the space beyond. Draw left vertical and bottom horizontal lines of generous length—these will become your left vertical and bottom horizontal border lines (Fig. 4). Tape the centered calligraphy to the drawing board (Fig. 5). Hold the tracing paper over the calligraphy, leaving, in your judgment, a proper margin of space between the calligraphy and the left and bottom margin lines (Fig. 6). To the right of the calligraphy, measure off a margin equal to the left margin and draw a vertical line. Where this vertical strikes the diagonal pencil line, draw a horizontal to the left to meet the left vertical. This completes the four border lines (Fig. 7). Center the calligraphy from side to side and from top to bottom within them. The borders may be enlarged or reduced proportionately along the diagonal until they look right to you. If you want to make the borders larger, draw a new vertical line further over to

Fig. 3

Fig. 4

Fig. 5

47

Fig. 6

Fig. 7

the right. It will strike the diagonal line at a higher point. Draw the new, higher top horizontal line. If you want to make the borders smaller, draw a new vertical line further in to the left. It will strike the diagonal line at a lower point. Draw the new, lower top horizontal line.

When you have decided upon the proper borders, transfer them to the page with the calligraphy text and draw them in with the non-repro blue pencil. Draw black crop marks (with a fine-tipped ballpoint pen or marker) one-quarter inch beyond the borders. Tape a piece of tracing paper over the face of the artwork for protection and write instructions to the printer beside the art: Print (number of) pieces on (kind of paper) stock in (color) ink by (agreed upon) date. Since the artwork will be proportionally larger than the actual size of the printed piece, you have to tell the printer how much to reduce it. If the borders of the art are 7⅞"× 11" and the printed piece is meant to be 5"×7", write: Reduce 7⅞"×11" to 5"×7". (If you know how to use a proportion wheel, you may determine the actual percentage yourself.) Use similar procedures in preparing art for RSVP cards or return addresses on envelopes.

Any cut marks on your original artwork

It is good policy to remind old contacts about your existence a couple of times a year, and it is easier if you have something new to offer.

will not show on the printed product, but bits of rubber cement or smudges will, so be sure to clean these off.

One caution: If you reduce the artwork excessively (over 50%—that is, 10"×14" to 5"×7"), your thin strokes will become very thin, and some may drop out in the printing. For this reason, always use deep black ink, but even so, don't reduce your work to less than half of its original size.

SOURCES OF WORK Contact the same clients you approached about addressing envelopes and tell them about your "new service." It is a good policy anyway to remind old contacts about your existence a couple of times a year, but it is easier if you have something new to offer.

Invitations in Calligraphy

The honor of your presence
is requested
at the marriage of
DEBRA ANGEL
and
HENRY WRIGHT
on Sunday
the seventeenth of May
three o'clock
at Grace Church
64th and Vine Street
New City

R.S.V.P.
before April 10, please
(211) 688-9052

Invitations for weddings, parties, and special occasions with a distinctive look.
Styles: *Italic,* Roman, UNCIAL, Blackletter.

For free estimate, call *(your name and number).*

בע"ה
בברכת ה' עלינו מתכבדים אנו
להזמין את כבודכם להשתתף
בשמחת כלולת בנינו היקרים
החתן משה דוב י"
עם בחירת לבו
חיה ניצע תחי'
שתתקיים א"ה בשעה טובה ומוצלחת
ביום ראשון בשבת ר"ח חשון התשל"ז
בשעה אחד-עשר בבוקר
בבית הורי הכלה המחותת
200 רח' שנונס-ושיט מערבית
ניו-יורק

הור' הכלה הור' החתן
מר אשר פן מר שמעון פוזנק
ורעיתו סאסיל ורעיתו פרומ'ע-יטרה

MR. AND MRS. ASCHER PENN
AND
MR. AND MRS. SIMON POSNICK
JOYFULLY INVITE YOU TO ATTEND
A RECEPTION TO CELEBRATE
THE MARRIAGE OF THEIR CHILDREN

EILEEN AND MICHAEL

ON SUNDAY, OCTOBER 24, 1976
AT 2:00 IN THE AFTERNOON
TERRACE ON THE PARK
111TH STREET AND 52ND AVENUE
FLUSHING MEADOW, QUEENS

delen u in blijdschap mede are pleased to announce
te zijn getrouwd in New York their marriage in New York
op 29 Januari 1984. on January 29, 1984.

Huidig adres: 122 West 80th Street, New York, N.Y. 10024 : At home

%o Mr. and Mrs. Jan van Leeuwen %o Mrs. Ruth Miner
Lijsterstraat 51 75 Circle Lane
Wormerveer 1521 XB Roslyn Heights, N.Y. 11577
The Netherlands U.S.A.

WE WILL GATHER TOGETHER
TO CELEBRATE THE LIFE OF

GLORIA STAVERS

TUESDAY, JULY 12TH, 1983
SIX IN THE EVENING
SAINT PETER'S CHURCH
LEXINGTON AVENUE
AT FIFTY-FOURTH STREET
NEW YORK, NEW YORK

YOU AND OTHER FRIENDS
ARE INVITED TO SHARE
YOUR MEMORIES OF HOW
GLORIA UPLIFTED YOUR LIFE
OR TO RELATE
A SPECIAL ANECDOTE ·
IF YOU CANNOT BE PRESENT,
BUT WISH TO SEND YOUR FEELINGS,
SOMEONE THERE
WILL BE HAPPY TO READ THEM
FOR ALL TO SHARE ·

EXPLORERS' CLUB of EDINBURGH

AWARD OF MERIT

presented to

Alexander MacLaren

for service in pursuit of mankind's horizons.

November 12, 1908 AS Gordon

You are cordially invited to

MONEY TALKS

A Mini-Seminar on Tax and
Retirement Planning for New
York's Top Executive Women.

Presented by E.F. Hutton
Hosted by Ladies' Home Journal

SPEAKERS

<u>LADIES' HOME JOURNAL</u>
Lenore Hershey, Editor

<u>E.F. HUTTON</u>
William L. Clayton, Senior Vice President
Maynard L. Engel, LLB, V.P., Financial
 Planning Director
Jean M. Patterson, AVP, Portfolio
 Manager, Director of Women's
 Investment Services
Richard R. Tartre, Senior Vice President

<u>INTERNAL REVENUE SERVICE</u>
Lilian Sohnen, Agent

Please join us to celebrate the

בַּר מִצְוָה

of our son

ELLIOT

on Saturday, December 15, 1979
at 10:30 A.M. Temple Israel
Scotland Road, South Orange N.J.
Reception following the service
Harris and Shoshanna David
R.S.V.P. by Nov. 30, (201) 763-2531

Clients may be impressed with the more decorative pieces in your portfolio but will often ask for simpler treatments because they cost less.

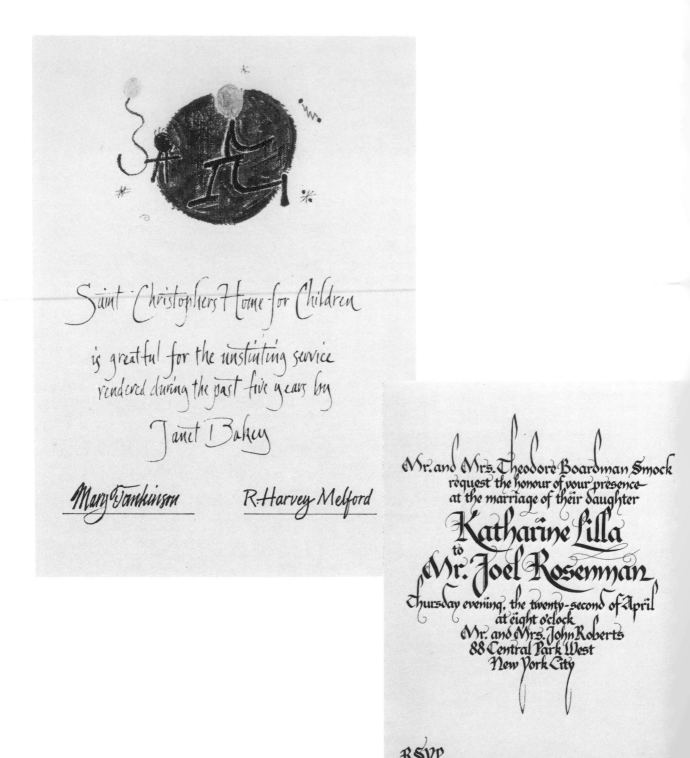

Saint Christophers Home for Children

is greatful for the unstinting service
rendered during the past five years by

Janet Bakey

Mary Tomkinson R. Harvey Melford

Mr. and Mrs. Theodore Boardman Smock
request the honour of your presence
at the marriage of their daughter
Katharine Lilla
to
Mr. Joel Rosenman
Thursday evening, the twenty-second of April
at eight o'clock
Mr. and Mrs. John Roberts
88 Central Park West
New York City

RSVP

GOLD SEAL VINEYARDS
presents to

Daniel Tate

for his outstanding sales performance
in
"A Taste of New York Dinner & Wine Experience for Two"

August, 1981

The American Stanhope Hotel

We, the management, and family
of the hotel commend you and
thank you for your continuing
dedication and hard work.

Employee of the Year

The Technique of Copyfitting

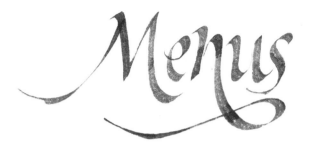

*L*ike invitations, menus are prepared in the form of a mechanical to be delivered to a printer. They are a greater challenge than invitations, though, because of the greater quantity of information to be arranged and fit into the page.

MATERIALS You may use any paper, pen, and ink you are comfortable with; you will also need a light box and paste-up supplies. In preparation, make up a set of guideline sheets for the nib sizes you use most frequently. For each nib size, draw up several sheets, each with the same x-height but with different line spacing. For instance, if the x-height is five nib widths, the line spacing for one sheet could be six nib widths, for a second eight nib widths, for a third ten nib widths, and so on. A difference in line spacing can change the "color" of a text subtly or drastically. Draw these sheets with an "O" technical pen on 11"×14" pieces of matte drafting film. Film allows for crisp pen lines and is transparent yet durable.

Make up a separate sheet of axis lines— vertical lines on an 11"×14" sheet. Held vertically behind a set of guidelines, it can be used for humanist and upright hands; held at an angle, it can be used for italic and Spencerian hands (Fig. 1).

SPECIFICATIONS The client should supply typewritten copy. Is the finished menu to be one, two, or more pages? If it's more than one page, where do they want the breaks to occur in the copy? (For instance, "Appetizers" and "Soups" on one page, "Entrees" and "Beverages" on another.) Find out the client's preference about lining up the items flush left or centering them, placing the price immediately after the item or across the page, and so forth. Could a category (like dessert) be divided into two columns to save space? Would they like to see a preliminary pencil sketch? Do they want ornamentation? Review their last menu with them, asking what they liked and disliked about it.

PROCEDURE The layouts of menus do not vary much. The next time you are waiting for service at a restaurant, make a thumbnail sketch of the menu. This will help you to analyze the basic elements of the menu layout: heading (usually the name of the restaurant), subheads (breakfast, lunch, dinner, wine list), sub-subheads (soup, salad, entrees, beverages, dessert), and the body copy (the individual items). It will also give you practice in doing thumbnails, which is the first step in designing a menu from typewritten copy.

In any calligraphic project, there are both design problems and technical problems. Solve a design problem well and you receive compliments: "That looks nice." Solve a technical problem and nobody notices. But if you *fail* to solve a technical problem, you will hear all about it with comments like: "Isn't the ink lighter on these letters than on the rest of the piece?" *or* "Doesn't that line slant up on the right?" *or* "It looks nice on the page but it's too small to read."

The last comment, "It's too small to read," touches on a technical problem you will face every time you do a menu: how to get all the copy to fit into a given page area and still be *legible*. Legibility is especially important, as menus are often used in rooms which are dimly lit. It sometimes helps to remember that the ultimate user of all your work is a human being like yourself; this is a common ground you can use to make decisions and answer countless questions.

When working with a small amount of copy (like an invitation), you can write out or rough out the whole draft until you find the size and proportions you like. A menu, however, has too much copy to write out in its entirety, so you have to use a shortcut: copyfitting.

How can you look at typewritten text and know how much space it will take up as calligraphic text? What size x-height, line spacing, and margins do you use so it will fit a given page area? After you do ten such translations, you will get a feel for them. Until then, there is a step-by-step method to find the way. You start with a little information and estimate for the whole. You see how that solution works out, make some adjustments, and re-estimate. Then you do a finished version, and if that does not come out exactly as you expected, there are still a few tricks left.

On a piece of tracing paper, draw the outlines of the final menu size in pencil. Lightly

It helps to remember that the ultimate user of all your work is a human being like yourself; this is a common ground you can use to make decisions and answer countless questions.

draw an interior rectangle indicating the approximate margins you want to leave around the texts. Making an educated guess, pick one of your guideline sheets. (If you haven't the faintest idea which to choose, pick the #3 nib with six nib widths line spacing. Remember, larger letters are more legible.) Slip the guidelines under the tracing paper and, inside the text area, write out a couple of lines of copy. From the length of these lines, estimate the total length of the block of copy it is in. Then estimate the lengths of the other blocks of copy. Draw these as rough rectangles with space between them (Fig. 2). If all of these rectangles do not fit the page size, there are two options—change the page size using the diagonal-proportion method, or start over with a different guideline sheet.

When you have a series of rectangles that approximately fit the page size (or proportional page size), slip the guideline sheet underneath and tape both sheets to the light box. On a piece of clean tracing paper placed over the

other two sheets, write out the first line or longest line of the first block of text. Judging by the length of that line, indicate the lengths of the remaining lines in that block, but don't actually write them out. In the same manner, comp in all the blocks of text, leaving plenty of space between the blocks (Fig. 3).

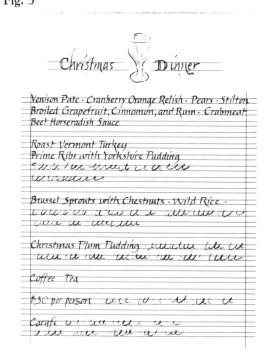

Fig. 1

Fig. 2

Fig. 3

If you're not happy with the way the rough comp looks, several adjustments can still be made at this stage. If your comp has too much text for the page: (1) the margins can be reduced and the text area enlarged, (2) the x-height can be reduced, (3) the line space can be reduced, (4) the space between blocks of copy can be reduced. Start by reducing the line space and/or space between blocks. Keep the x-height large for legibility and the margin ample for breathing space. If your rough comp is too small for the page, the same elements can be enlarged instead of reduced.

When you've made all your adjustments, proceed to the finished calligraphy (Fig. 4). If you are using a centered layout, employ one of the centering methods you learned in designing invitations. Refer to that chapter, as well, for putting together the mechanical.

Even if something does not fit at this final stage, all is not lost. For instance, one of the blocks of text may run on longer than you estimated in the rough comp. In that case, cut apart all the blocks of copy and position them more closely together. The outside borders can still be enlarged proportionally. Don't despair, there is always *something* you can do to make the elements fit.

Before you take your mechanical off to the printer, consider the quantity of printed pieces your client has specified. A small restaurant does not need many menus and, if they frequently change dishes or prices, they probably want to keep their printing bills down. It may prove expedient to use the copy machine. "Wet" copiers require specially coated paper, while others (plain paper copiers) can reproduce your calligraphy on a wide variety of attractive papers. Even parchment paper, which is so difficult to work on directly, can be effectively used here. One caution: If you plan to use a copier, find out what sizes of paper it uses and design your menu to fit these dimensions.

ORNAMENTATION You may use ornaments and borders to add decorative touches to menus and many other projects (Fig. 5). These may be culled from a number of sources. Type books often have a few end pages of printer's ornaments which can be purchased from a typesetter and pasted into a mechanical. Art stores carry books of ornaments and designs (Dover Publications Inc. publishes many of these) which can be reproduced without copyright restrictions. This artwork may be photostated or reproduced on a quality copier machine and added to a paste-up. Several companies that make pressure-sensitive type sheets include decorative material in their collections. Much of this material has a machine-made look that does not complement hand-lettering. To achieve a better blend, try tracing or re-drawing the designs by hand with the pointed or broad-

Fig. 4

Christmas Dinner

Venison Paté · Cranberry Orange Relish · Pears -Stilton
Broiled Grapefruit, Cinnamon, and Rum · Crabmeat
Beet Horseradish Sauce

Roast Vermont Turkey
Prime Ribs with Yorkshire Pudding
Striped Bass - Minced Clam Stuffing
Roast Fresh Ham

Brussel Sprouts with Chestnuts · Wild Rice · Glazed
Baby Carrots · Roast Potato · Cauliflower Sauteed
in Cream Spinach

Christmas Plum Pudding · Mincemeat Pie · Baked
Apple in Pastry · Saratoga Hot Fudge Sundae

Coffee Tea

$30⁰⁰ per person Tax & Service not included

Carafe of House Wine
Large - $13⁰⁰ Small - $7⁰⁰

Type Ornaments

Courtesy Boro Typographers, Inc.

Courtesy Boro Typographers, Inc.

Calligraphic Ornaments

Fig. 5

edge pen. Books on calligraphy often show examples of pen-crafted ornaments. You may practice and copy these in the same way you learn a new hand.

SOURCES OF WORK It's easy to locate the market for menus: restaurants and caterers. Start with your own neighborhood. Take some sample menus around—between lunch and dinner—and ask for the owner or manager. Restaurants are not like offices; you can walk in without an appointment. They might even be interested in bartering a menu for free meals.

If you would like to do a mailing, send good quality copies of sample menus and a cover letter. Actual-size samples are more convincing than reduced illustrations on a flyer.

Soup of the Day 3.00

O'Henry's Chelsea Chili cup 3.25 bowl 4.25

Miss Eloise Vashner's Tea Sandwiches 4.00

Third Ave. El Foot Long Hot Dog 3.50

The "Blue Light Drugstore"
Hamburger 5.50 Cheeseburger 6.50
(Sharp Cheddar, American, or Swiss)
Served with Galery Fries

Sprowls and Mooney Hot Chicken Sandwich
(Served on Soda Bread) 5.50

Mrs. Purdy's Virginia Ham Sandwich
(Served on Pumpernickel Bread) 6.25

Galery Fries 1.25

Toast and Jam 2.25

Desserts
Henry Hudson's Hot Fudge Sundae 3.50
Butterscotch Sundae 3.50
Black Velvet Torte 3.75
Raspberry Nut Torte 3.75
Cheese Cake 3.75

Teas
Earl Grey English Breakfast
Red Zinger Orange Pekoe (150)

Mrs. McCool's Chocolate Egg Cream 2.00

Milk Shakes 2.25

Coffee 2.00 Milk 1.75
Sanka 2.25 Espresso 2.75

Wine
Small Carafe 7.00 Large Carafe 13.00

SKINFLINT'S
EATING & DRINKING ESTABLISHMENT

ONCE AN ICE CREAM PARLOR [1912], NOW A DISTINCTIVELY DIFFERENT BAR AND RESTAURANT

FOR OUTGOING ORDERS CALL 745-8782

ASK YOUR WAITRESS ABOUT OUR DAILY SPECIAL

FOR STARTERS
Onion Soup
Soup of the Day
Antipasto
Chili

SALADS
Diet Salad
House Salad
french, russian, italian & blue cheese dressing 25¢ extra

FROM THE SEA
Fish & Chips
Fried Shrimp
Deep Sea Scallops
all served with cole slaw, french fries & tartar sauce

FROM THE RANGE
Steak
Chopped Steak
both with salad & french fries

BURGERS
Bacon Cheeseburger
Baconburger
Cheddarburger
Swissburger
Onionburger
Cheeseburger
Hamburger
all served with french fries, cole slaw, pickle & choice of English Muffin or Burger Bun

SANDWICHES
Bacon, Lettuce & Tomato
Grilled Cheese, Bacon & Tomato
Grilled Cheese & Tomato
Grilled Cheese
Tuna Delight

DESSERT
New York's Finest Cheesecake
Cherry Cheesecake
Strawberry Cheesecake
Irish Coffee

BEVERAGES
Coffee
Tea
Sanka
Milk
Soda

Dinner

APPETIZERS

Saratoga Paté 6^{50}
Louisiana Shrimp Cocktail 9^{50}
Barnegat Bay Clams on Half Shell 6^{50}
Chesapeake Bay Crabmeat Cocktail 9^{50}
Smoked Washington Salmon 8^{50}
Marinated Mussels 6^{00}
Pickled Bayou Shrimp 9^{50}

SALADS

Tossed Salad 5^{00}
California Fresh Fruit Salad 5^{75}

SOUPS

Cream of Carrot 3^{75}
Pilgrim Pumpkin 3^{75}
Lobster Bisque 4^{25}

Margaux

Chateau Margaux 1959
Chateau Palmer 1974
Chateau Palmer 1976
Chateau Brane-Cantenac 1970

Pauillac

Chateau Lafite-Rothschild 1970
Chateau Pichon-Longueville,
Comtesse de Lalande – 1971

German Wines

Rhine

Regionals

			Bottle
250	Madrigal Liebfraumilch	½	9.00
251	Madrigal Niersteiner Domtal	½	9.00
252	Madrigal Johannisberger Riesling	½	9.00

Estate Bottled

253	Deidesheimer Paradiesgarten Kabinett E.A. Von Bassermann-Jordan	*1973	12.00
254	Schloss Johannisberger Orangelack Kabinett E.A. Furst Von Metternich	*1973	14.00
255	Schoss Vollrads Kabinett E.A. Graf Matuscha	*1971-73	14.00
256	Rudesheimer Berg Rottland Riesling E.A. Schlotter	*1971	16.00

*Denotes limited quantity

Your Developing Craft

Addressing envelopes, filling in names on certificates, and creating signs, invitations, and menus are all jobs you can do as a beginner. As you progress in your craft, you will execute these jobs with ever greater ease and skill. But as you become competent at turning out these projects, you will no doubt want to develop craft skills to satisfy your own aesthetic needs, needs which go beyond the immediate market requirements. This chapter covers several projects which will help your development as a craftsman although they may not immediately affect your earning power.

The section on business cards and stationery, for instance, will help advance your design sense. Creating greeting cards for yourself or friends will help increase your knowledge of preparing art for the printer. And making personalized T-shirts and other items is a way to have fun, satisfy your gift list (and quite possibly turn a small profit as well). But let's assume that for the time being you will be doing these projects for *free*—either for personal satisfaction or as a favor for friends. The idea is that if you don't have to satisfy a paying client, you have greater freedom to enjoy, learn, and grow in some of the more creative areas of the craft.

As you become competent at turning out projects, you will want to develop craft skills to satisfy your own aesthetic needs, needs which go beyond the immediate market requirements.

Since I mentioned in the introduction that the chapters in this book are arranged in order of ascending difficulty, why does a chapter on working for nothing come at the end?

Because we can be very hard on ourselves, harder than most clients. We start out with a generous urge to do something beautiful and soon can find ourselves in despair over the particular piece and doubting our talent in general. "It just isn't good enough," and "I can't get it to look right" are recurrent plaints. "Why am I wasting all this time on this nonsense?" is no less familiar. These are all indications that you have strayed beyond "functional" craft and entered the realm of creativity.

Who ever said art was easy?

BUSINESS CARDS AND STATIONERY

Review the material on business cards in the Introduction (under "Promotion Pieces"). The emphasis on simplicity as presented there provides a good starting point for more sophisticated efforts.

SPECIFICATIONS No special materials are needed, but you would do well to supplement my instructions with a book or a course on graphic design. The only specifications you need to determine are paper stock, ink color, and size. (Business cards are usually "gang printed," meaning that you supply the printer with one camera-ready mechanical, he duplicates it, prints several cards at once on one large sheet of card stock, and trims them down to size.) The standard business card size is 2" × 3½" but if you look through the cards in your own wallet, you will find other acceptable measurements. Standard size business stationery is 8½"×11" and matching envelopes are referred to as #10 envelopes. Standard personal stationery is 7¼"×10½" and fits envelopes 4"×7½".

PROCEDURE After you've landed a few paying jobs you will probably become aware of this law: People want what they are accustomed to. Today they are accustomed to italic and identify that hand as calligraphy. In choosing the style for a job, they will say, "It should be beautiful but not too fancy, something you're able to read." This means italic. Clients may admire the arty samples in your portfolio, but when they place the job order, it's for italic.

We can be very hard on ourselves, harder than most clients.

When you're working for free, though, other options open up. If you've offered to design a business card for a friend, he obviously expects to have final approval of the design, but you can approach the job differently. Instead of letting him point to a piece in your portfolio and say "Do it like that," show him the work of people you admire and would like to emulate or sketches of your own new designs. The best time to take risks and exercise creative freedom is when you're not being paid.

In the previous chapters you've learned how to design a piece and prepare a finished mechanical. These are all the procedures needed to create business cards and stationery. I've provided a number of examples of my own successes and failures in this area—study these, add your own ideas, and take the plunge.

GREETING CARDS

Greeting cards are another nonprofit area. While it is possible to sell your designs to card companies (they do not pay well as a rule) or produce your own and sell them to stationery

stores and card shops, most calligraphers use greeting cards as personal expressions of friendship. Cards are also useful for sending to clients as friendly reminders both of your existence and of your skill.

SPECIFICATIONS You do not need special tools, but again, a course or a book on preparing art for reproduction would be helpful. Like business cards, greeting cards are cut down from large sheets of paper. We will discuss the most common kinds of greeting cards here—postcards and folded cards in envelopes. The most popular sizes of postcards are 3½"×5½" (U.S. postcard size), 4⅛"×5⅞", and 6"×9". For folded cards, work back from the envelope size you're using and design the card so that when it's folded, it measures ¼" less in length and width than the envelope size. (If the envelope is 5¼"×7¼", the folded card should be 5"×7".)

PROCEDURE There is no step-by-step method that will guide you through the creative process of designing a card, but there is a starting point. Begin by considering the method of printing or reproduction that you can afford. This will limit the possibilities—not restrict your imagination, but set the rules for the game. If you cannot afford to have a four-color printing job, design for two colors. If you cannot afford a heavyweight, matte coated stock, design for a lightweight, uncoated stock. If you cannot afford folded cards in envelopes, design for postcards. Once you have the "givens," you can respond creatively. What color ink goes well with this color paper? On this texture paper, should the letters be cleanly stroked or ragged edged? On this size postcard, how many words can be used? Once you answer these questions, inspiration will follow.

Let's start with the least expensive card to produce: the postcard. It saves the cost of an envelope as well as some postage. The least expensive way to reproduce postcards is by copier machine. You may look into offset printing, but copy shops generally have better prices for small quantities. (They will also run off any number you want, whereas printers have minimum quantities.) Moreover, the quality of a good copier is superior to offset; the black is more opaque than printer's ink and holds thin lines better.

Printers and copy shops usually stock paper in different colors, textures, and weights. Ask them about other sources of supply: art stores, stationery stores, and job lot shops. (A job lot

Fig. 1

shop buys overruns from paper manufacturers. You never know what they will have, but it is inexpensive.) Also ask them about postal regulations for the weight of postcards. They should know if their card stock meets those requirements.

Greeting cards are useful for sending to clients as friendly reminders both of your existence and of your skill.

The card in Fig. 1 was printed on ivory stock. The body copy was reproduced in black, and I filled the capital in by hand, in red. To make the mechanical, I simply pasted the completed calligraphy down on an 8½"×11" page and drew in crop marks. Then I had it run through a copy machine and cut the cards out along the crop marks. It may seem like a waste of paper to cut one postcard out of an 8½"×11" piece of stock. In this case, however, I wasn't going to print very many cards, and the time it would take to gang up multiple mechanicals on one page, run them off, and cut them apart wasn't worth the effort compared to the minimal cost of printing a small quantity. Twenty-five copies on ivory card stock cost a total of $2.50.

While in this example I colored in the initial capital by hand, another way to add color inexpensively is with a rubber stamp (Fig. 2). A stamp will let you use an ornate capital and is easier to use for large quantities of cards. If your initial capital or ornament is simple, you can cut your own stamp out of an eraser with an X-acto knife. If the design is intricate, look up "Rubber Stamps" in the Yellow Pages and have one made. Stamps will admit a surprising amount of fine detail and have even been used successfully for calligraphy. In addition to the

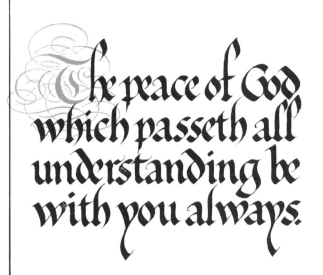

Fig. 2

ordinary selection of ink pad colors, special colors can be made to order. You can also color the stamp with a marker.

If you want to use folded cards in envelopes, start by locating the envelopes. Printers, art stores, stationery stores, and job lot shops are good possibilities. And of course, you can look up "Envelopes" in the Yellow Pages. Paper and envelope manufacturers may not want to bother with the small quantities a calligrapher needs, but who knows what overstock is crowding their shelves that they might be giving away? When Christmas cards are sold for half price in January, stock up; sometimes envelopes are separated from their cards and can be purchased quite inexpensively.

Cards may be folded once or twice. The advantage to the second fold, called a French fold (Figs. 3a and 3b), is you can have matter printed on the front and inside of the card and only pay for printing on one side of the paper. In choosing the dimensions of your card, remember to leave ⅛" clearance on all sides from the envelope.

Fig. 3a

Fig. 3b

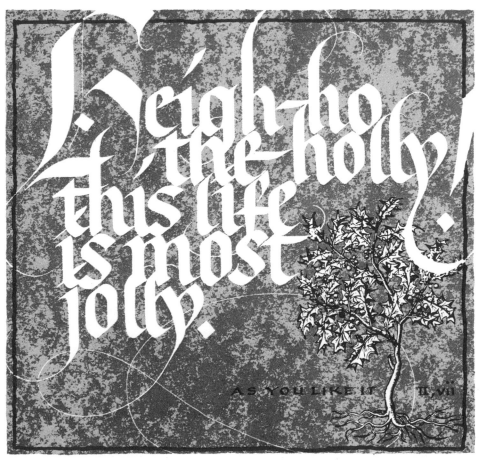

Some say, that ever 'gainst that season comes
Wherein our Savior's birth is celebrated,
This bird of dawning singeth all night long;
And then, they say, no spirit can walk abroad;
The nights are wholesome; then no planets strike,
No fairy takes, nor witch hath power to charm,
So hallowed and so gracious is the time.

Shakespeare

It was Christmas night in Camelot and all around
the castle the snow lay as it ought to lie. It hung heavily
on the battlements like thick icing on a very good cake, and
in a few convenient places it modestly turned itself into
the clearest icicles of the greatest possible length. It hung
on the boughs of the forest trees in round lumps, even better
than apple blossom, and occasionally slid off the roofs
of the village when it saw the chance of falling on some
amusing character and giving pleasure to all. T.H.White

The long quotations by Shakespeare and by T. H. White were designed to be reproduced by copier on the end of 8½″ × 11″ paper and folded into a #10 envelope.

PERSONALIZED T-SHIRTS

I have a feeling that this project could make some of you a fair amount of money, especially if you have the gumption of a ten-year-old lemonade stand entrepreneur. At the very least, you should enjoy experimenting with a new medium and surface.

MATERIALS You'll need a couple of dozen all-cotton T-shirts in assorted sizes; a piece of shirt cardboard; a few sizes of broad pens from ½" to 1"; square-cut, stiff bristle brushes from ½" to 1"; water-soluble textile paint in black and a couple of colors of your choice (mix this with water to the consistency of gouache); a pad of 11"×14" bond paper and broad, chisel-tip markers.

PROCEDURE When your pen first glides down the surface of cloth, I hope you experience the same thrill I did. The kitten enjoys the hand's caress, but so does the hand enjoy the feel of the kitten. The feel of cloth transmitted back to the hand via a pen or brush can be very satisfying. Cloth absorbs paint faster than paper does ink, and you have to learn how much to load your pen so as to keep from running out in mid-stroke.

An alternative to the wide dip pen is the square cut, stiff bristle brush. After trying a variety of expensive art store models, I discovered that the cheap sign brushes sold in hardware stores work better. Stiffness is the only property that matters. Brushes hold more paint than pens and allow you to work more quickly. But they are also flexible where the metal pen is rigid and call for an entirely different touch. The right touch cannot be communicated through the page of a book—do it for a couple of days and it will come.

If you want to letter a name on a T-shirt, first sketch the name with a marker on the pad of paper to check for fit. Long names can be slanted diagonally. It is possible to slip this sketch under the T-shirt and do the finished work on a light box. Or, you can make light pencil indications on the shirt. Once you get into the swing of it, you'll be dashing off the finish without any aids. Before applying the paint, slip the shirt cardboard into the shirt to prevent paint from bleeding through. After the textile paint dries, iron the back of the fabric. This makes it non-stiffening and permanent in a normal, hot-water wash (check the directions on the textile paint to confirm this).

A rendering of an actual job. If you take the time to look this word up, then you're probably a sesquipedalian.

To sell T-shirts personalized in calligraphy, make contact with a street fair, a country fair, or a summer resort—in short, any place where an open-air stand can be set up and people gather to purchase gifts. You can prepare some shirts in advance with quotes already inscribed on them or, like a sidewalk portrait artist, do people's names on the spot. There is a capital

risk in buying the T-shirts—guessing how many of which sizes and in what colors—but that's what it takes to set up shop for yourself. If T-shirts take off, you might consider tote bags, aprons, canvas belts, or—if you get really confident—silk scarves and blouses.

I once tried to establish contact with T-shirt shops around New York City, asking them to display my samples and take orders for calligraphic names. It did not work out because my delivery time was too long and their markup on my charge was too high. If you live or work near a department store, clothing store, or even a copy shop that turns out personalized The greatest benefit derived from being a pro-

fessional calligrapher has nothing to do with money. Money has its uses, but less obviously professional experience has provided you with an incentive for developing your craft and while you were exerting yourself on behalf of your clients, you were becoming a better calligrapher. You were aware of this, of course, but take a couple of minutes to reflect on this particular benefit, and to recall what drew you into calligraphy in the first place. Would it be going overboard to call it magic?

shirts, you might be able to set up a quick delivery system. Otherwise, it's back to the lemonade stand.

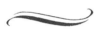

The magic of beautiful writing is a legacy that traces back through the ages. The oriental cultures have long prized calligraphy as the central art form. To wit, this Islamic tribute: "Handwriting is jewelry fashioned by the hand from the pure gold of intellect. It also is brocade woven by the pen with the thread of discernment...it functions as a manifestation of the intangible and eternal divine."

Each of us has his own favorite quotation—words to live by—but as a calligrapher *you* have the skill to render these words beautifully, even memorably. The most elevating thoughts, the most sublime sentiments—"what oft was thought, but ne'er so well expressed"—can become cherished keepsakes through your

The greatest benefit from being a professional calligrapher is the incentive it provides for developing your craft—the magic of beautiful writing.

craft. As you create these special pieces for friends and lovers, do not neglect yourself. What special words would you like to see framed over your drawing board or in your living room? Choose a passage that touches you deeply...and let your craft work its magic.

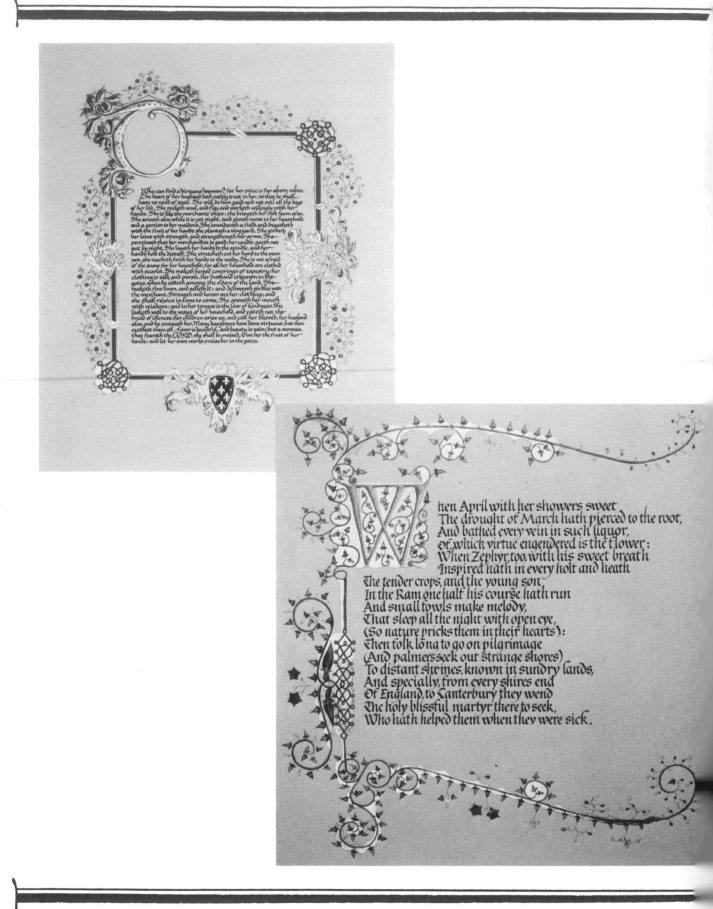

Whe can find a virtuous woman? for her price is far above rubies. The heart of her husband doth safely trust in her, so that he shall have no need of spoil. She will do him good and not evil all the days of her life. She seeketh wool, and flax, and worketh willingly with her hands. She is like the merchants' ships; she bringeth her food from afar. She ariseth also while it is yet night, and giveth meat to her household, and a portion to her maidens. She considereth a field, and buyeth it: with the fruit of her hands she planteth a vineyard. She girdeth her loins with strength, and strengtheneth her arms. She perceiveth that her merchandise is good: her candle goeth not out by night. She layeth her hands to the spindle, and her hands hold the distaff. She stretcheth out her hand to the poor: yea, she reacheth forth her hands to the needy. She is not afraid of the snow for her household: for all her household are clothed with scarlet. She maketh herself coverings of tapestry: her clothing is silk and purple. Her husband is known in the gates, when he sitteth among the elders of the land. She maketh fine linen, and selleth it; and delivereth girdles unto the merchant. Strength and honor are her clothing; and she shall rejoice in time to come. She openeth her mouth with wisdom; and in her tongue is the law of kindness. She looketh well to the ways of her household, and eateth not the bread of idleness. Her children arise up, and call her blessed; her husband also, and he praiseth her. Many daughters have done virtuously, but thou excellest them all. Favor is deceitful, and beauty is vain: but a woman that feareth the LORD, she shall be praised. Give her the fruit of her hands: and let her own works praise her in the gates.

When April with her showers sweet
The drought of March hath pierced to the root,
And bathed every vein in such liquor,
Of which virtue engendered is the flower;
When Zephyr, too, with his sweet breath
Inspired hath in every holt and heath
The tender crops, and the young son
In the Ram one half his course hath run
And small fowls make melody,
That sleep all the night with open eye,
(So nature pricks them in their hearts);
Then folk long to go on pilgrimage
(And palmers seek out strange shores)
To distant shrines, known in sundry lands,
And specially, from every shires end
Of England, to Canterbury they wend
The holy blissful martyr there to seek,
Who hath helped them when they were sick.

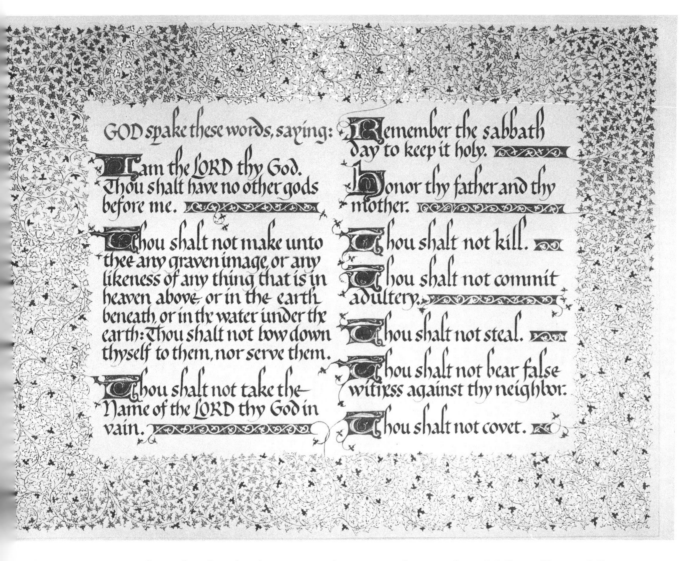

GOD spake these words, saying:

I am the LORD thy God. Thou shalt have no other gods before me.

Thou shalt not make unto thee any graven image, or any likeness of any thing that is in heaven above, or in the earth beneath, or in the water under the earth: Thou shalt not bow down thyself to them, nor serve them.

Thou shalt not take the Name of the LORD thy God in vain.

Remember the sabbath day to keep it holy.

Honor thy father and thy mother.

Thou shalt not kill.

Thou shalt not commit adultery.

Thou shalt not steal.

Thou shalt not bear false witness against thy neighbor.

Thou shalt not covet.

These pieces using traditional medieval and renaissance designs were done jointly with fellow gilders and illuminators.

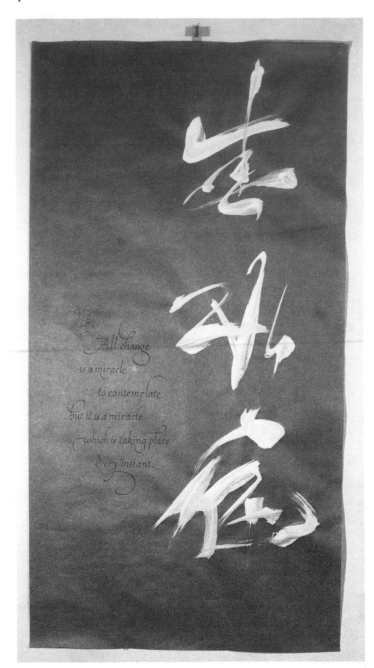

All change
is a miracle
to contemplate
but it is a miracle
which is taking place
every instant.

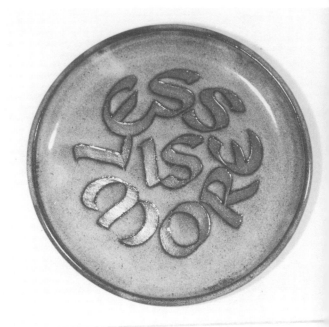

Above, ceramic plate with inscribed letters, after a design by Dee Dee Williamson.

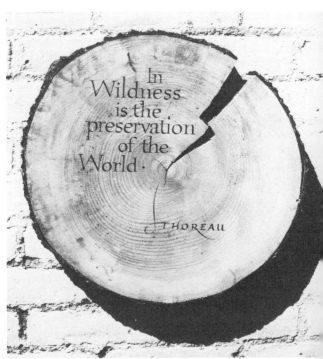

In
Wildness
is the
preservation
of the
World.

THOREAU

Contemporary treatments done on brown wrapping paper, above left; a cross-section of a log, right; a cloth with Indian hand-blocked design, opposite page, top; and papyrus (the quotation is a translation of the hieroglyphics which are also on papyrus), opposite page, bottom.

BLOW WIND
TO WHERE MY LOVED ONE IS,
TOUCH HER
AND COME AND TOUCH ME SOON:
I'LL FEEL HER GENTLE TOUCH
THROUGH YOU
AND MEET HER BEAUTY
IN THE MOON
THESE THINGS ARE MUCH
FOR ONE WHO LOVES—
A MAN CAN LIVE
BY THEM ALONE.

RAMAYANA

do not boast about your knowledge,
and do not trust yourself too much
because you are a learned man,
but take counsel with the ignorant
as with the wise. One cannot reach
the limits of art. A good discourse
is more hidden than the precious green
stone, nevertheless, one finds it with
the slave women over the millstones.

The Wisdom of Amenemope

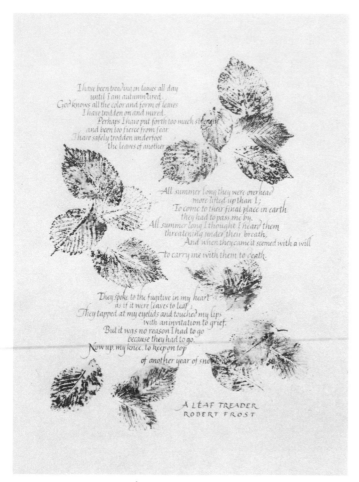

The leaf prints (made with actual leaves and water soluble printer's ink) are warm gray and the calligraphy is vermillion.

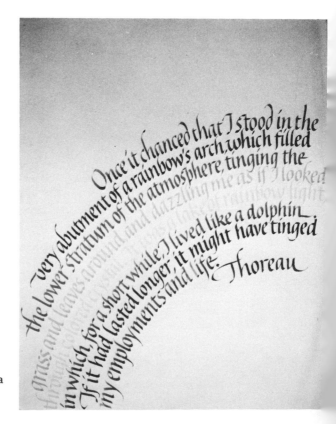

Using gouache paint, each line was done in a color of the rainbow.

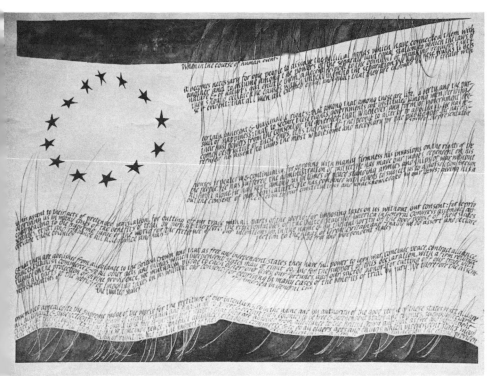

The piece above was completed for an exhibit the Society of Scribes held to commemorate the Bicentennial of 1976. The stars and background were done in blue gouache, the stripes were done in red ink.

One cannot collect all the beautiful shells on the beach.
One can collect only a few,
and they are more beautiful if they are few.
Gradually, one discards and keeps just the perfect specimen.
One sets it apart by itself,
ringed round by space —
like an island.

For it is only framed in space that beauty blooms.
Only in space
are events and objects and people unique and significant —
and therefore beautiful.
Even small and casual things take on significance
if they are washed in space,
like a few autumn grasses
in one corner of an Oriental painting,
the rest of the page bare.

Anne Morrow Lindberg

The seashell demonstrates a contemporary use of gold leaf on gesso.

Appendix

"A good craftsman is someone who knows how to correct his mistakes."
—Donald Jackson

You will take that definition to heart when you are slipping a job into its protective envelope —a job that has taken two days to complete —and, in giving it a last, loving glance, you discover a misspelling in the headline. This only has to happen once before you become convinced that you must be as skilled in making corrections as in any other technique you have learned.

In your early, smaller jobs, you may simply do a piece over if you spot an error. But when you begin doing projects which are lengthy or complex, this solution is impractical and costly. Discovering an error in a big job gives you the incentive to learn to make corrections proficiently. There are a number of different techniques, some best suited to work that will be printed, others to one-of-a-kind, original pieces.

CORRECTING ART FOR REPRODUCTION It is common to use inexpensive materials for this kind of work, since the actual ink on the actual paper is not what appears in the reproduction. For years, I used fountain pen ink on bond paper because I liked the way they handled, but this combination caused problems in corrections. Fountain pen ink, like most bottled ink, is not waterproof and cannot be covered by water-soluble white paint. The water in the paint reactivates the ink and causes it to bleed into the white. A few coats of white paint may still end up gray, and even several coats of spray fixative do not guarantee that the paint can cover the ink in one coat. When you have to apply two or three coats of paint, you may make new mistakes.

The best solution to the problem is to use stick ink instead of non-waterproof ink. Beginners often shy away from stick ink because it is not as convenient as the bottled variety, but in the long run it is superior for its opaqueness, for making hairlines, and for corrections since

mistakes can be covered completely in a single application of white paint.

Alternatively, any type of typewriter correction fluid which comes with a bottle of thinner covers water-soluble ink in one coat. It dries on the brush very quickly, though, so try pouring a little correction fluid and a little thinner into adjacent depressions in a paint tray and work your brush back and forth between them to keep the mixture fluid.

Bleach works beautifully on the black of photostats as well as on ink used on stat paper. It works tolerably well with non-waterproof ink on regular paper. Squeeze a few drops onto the mistake with an eye dropper (brushing it on may stir up the ink and spread it around). When the color of the ink fades, blot gently with a paper towel. When the paper dries, remove the rest of the ink with an eraser. Bleach will not eradicate sticking ink or gouache.

There are also some "quick and dirty" methods that often work quite well. They include covering up errors with white tape or white paper, or rewriting a word or letter and carefully pasting it over the original. Beware, though: a small piece of paper may come loose in transit or handling. As an added precaution, tape it, too.

CORRECTING ORIGINAL ART When mechanicals are photographed in preparation for making a plate, pieces of white tape and cut marks disappear. The printer's camera reduces everything to pure black and white. Original art, however, must be treated so the correction is invisible to the naked eye.

The two favorite tools of the trade for correcting originals are the electric eraser and the single-edge razor. Despite my peers' acclaim for the electric eraser, I balk at the cost and do not own one. But I have had considerable success in cutting two inches away from the eraser end of pencils and inserting this segment in my old ⅜" power drill. Used in combination with hand-held coarse (ink) erasers and fine (white rubber and kneaded) erasers, it does a fine job and resurfaces the paper so that re-inking will not bleed. (Some people resurface their paper with a shark's tooth or animal bone.)

The drill can be a bit cumbersome, though, and lately I have been reaching more and more for the razor. By a gentle, almost imperceptible scraping with the sharp edge held almost parallel to the surface, the ink comes off at a satisfactory rate and the surface of the paper is not marred. I use white and kneaded erasers for the final resurfacing.

All corrections should be tested on samples of the paper and ink you will be using, so as to avoid surprises on the final piece. You may find that even the gentlest touch will wear away the surface color of the paper and reveal a lighter interior. Colored pencils can be used for touch-ups in such cases. If a spot has completely penetrated the paper so that surface abrasion will not do the trick, try bleach or paint. If you use paint, lay down a white coat first and then add a tint to match the paper. Feather the edges to blend the correction into the surrounding area.

There is one kind of pride you feel when a client praises the beautiful work you have done. There is another feeling of pride that comes when the client does not spot a carefully corrected mistake.

The poet
makes himself a seer
through a long
a prodigious and
a rational disordering
of all the senses.

Rimbaud